Anthony van Dyck

Thomas Howard
The Earl of Arundel

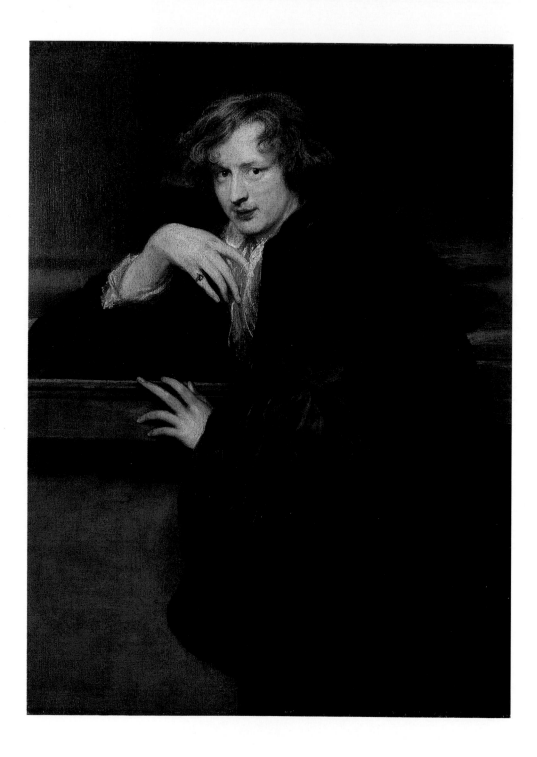

Anthony van Dyck

Thomas Howard
The Earl of Arundel

Christopher White

**GETTY MUSEUM
STUDIES ON ART**

Malibu, California

Christopher Hudson, *Publisher*
Mark Greenberg, *Managing Editor*

Dagmar Grimm, *Editor*
Elizabeth Burke-Kahn, *Production Coordinator*
Jeffrey Cohen, *Designer*
Louis Meluso, *Photographer*

© 1995 The J. Paul Getty Museum
17985 Pacific Coast Highway
Malibu, California 90265-5799

Mailing address:
P.O. Box 2112
Santa Monica, California 90407-2112

Library of Congress
Cataloging-in-Publication Data

White, Christopher, 1930–
 Anthony van Dyck : The Earl of Arundel /
 Christopher White.
 p. cm. — (Getty Museum studies on art)
 Includes bibliographical references.
 ISBN 0-89236-342-8
 1. Van Dyck. Anthony. Sir. 1599–1641. Earl
 of Arundel. 2. Arundel, Thomas Howard,
 Earl of, 1585–1646—Portraits. 3. Van Dyck,
 Anthony, Sir, 1599–1641—Criticism
 and Interpretation. 4. J. Paul Getty Museum.
 I. Van Dyck, Anthony, Sir, 1599–1641.
 II. J. Paul Getty Museum. III. Title.
 IV. Series.
 759.9493—dc20 94-42442
 CIP

Cover:
Anthony van Dyck (Flemish, 1599–1641)
Thomas Howard, The Earl of Arundel (1585–1646),
circa 1620/1 [detail]
Oil on canvas, 102.8 × 79.4 cm (40 ½ × 31 ¼ in.)
Malibu, J. Paul Getty Museum (86.PA.532)

Frontispiece:
Anthony van Dyck
Self-Portrait, circa 1620/1
Oil on canvas, 119.7 × 87.9 cm (47 ⅛ × 34 ⅝ in.)
New York, Metropolitan Museum of Art, Bache
Collection (49.7.25).

All works of art are reproduced (and photographs
provided) courtesy of the owners unless otherwise
indicated.

Typography by G & S Inc., Austin, Texas
Printed by C & C Offset Printing Co., Ltd.,
Hong Kong

CONTENTS

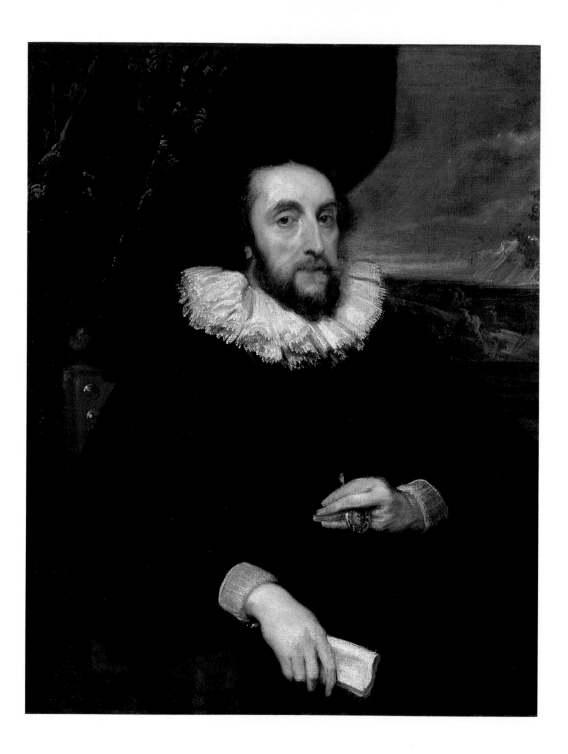

The Portrait

Around the turn of 1621, Anthony van Dyck [FRONTISPIECE], on his first brief visit to London, painted the portrait of Thomas Howard, second Earl of Arundel [FIGURE 1, FOLDOUT].[1] This journey, which marked the outset of what was to become a brilliant international career, allowed Van Dyck to escape from the shadow of Rubens in Antwerp and establish himself as an increasingly individual and sophisticated artist, who in the course of the next two decades was to portray some of the leading figures in Europe. The present sitter was not only one of the most important members of the court of James I but was to prove to be one of the greatest and most enlightened collectors and patrons England has ever known. Sitter and artist were in their different ways eminently worthy of one another, and the portrait marked the first stage in a remarkable history of patronage.

The earl, depicted three-quarter-length, is seated on a high-backed chair before a curtain with a woven pattern on the left. Bare-headed, he is dressed in black with a wide, falling ruff. The long, tapering fingers of his left hand [FIGURE 2] enclose the jewel of the Lesser George, the badge of the Garter, which is suspended from the ribbon of the Order around his neck, while his right hand encloses a scroll of paper. In the landscape background on the right, the sun breaks through the clouds on rolling wooded countryside more reminiscent of the scenery of southern England than anything to be found in the southern Netherlands.

The elongated, pale face [FIGURE 3] set off by the ruff and the somber clothing contrast with the scarlet chair embossed with golden buttons and the dark, wine-red patterned curtain. The expression on the face, with its striking Roman nose, is alert but reserved as he turns slightly to look out at the spectator. The movement of the hands is natural and relaxed. The portrait conveys the image of a distinguished and aloof aristocrat, which accords well with a contemporary description of the sitter written fifteen years later: "He was tall of Stature, and of Shape and proportion rather goodly than neat; his Countenance was Ma-

Figure 1
Anthony van Dyck
*Thomas Howard,
The Earl of Arundel
(1585–1646),* circa
1620/1. Oil on canvas,
102.8 × 79.4 cm
(40½ × 31¼ in.).
Malibu, J. Paul Getty
Museum (86.PA.532).

1

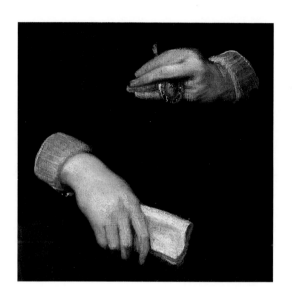

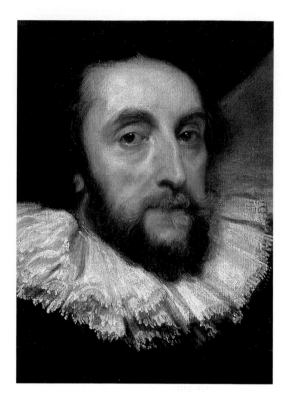

jestical and grave, his Visage long, his Eyes large, black and piercing; he had a hooked Nose, and some Warts or Moles on his Cheeks: his Countenance was brown, his Hair thin both on his Head and Beard; he was of stately Presence and Gate, so that any Man that saw him, though in ever so ordinary Habit, could not but conclude him to be a great Person, his Garb and Fashion drawing more Observation than did the rich Apparel of others; so that it was a common Saying of the late Earl of Carlisle, Here comes the Earl of Arundel in his plain Stuff and trunk Hose, and his Beard in his Teeth, that looks more a Noble man than any of us."[2]

THE SITTER

Born in 1585, Thomas Howard was thirty-five or thirty-six when the portrait was painted, and it coincided with an auspicious time in his life. After the difficult years of his childhood and youth, his fortunes were improving under the reign of James I. Thirteen years before his birth, his grandfather Thomas, fourth Duke of Norfolk, had been executed under an order of Queen Elizabeth I for supporting the cause of Mary, Queen of Scots. The dukedom was attainted and the family estates and possessions confiscated by the Crown. And family history repeated itself in the year of the sitter's birth, when his father, Philip, who remained a staunch Catholic, was imprisoned by Elizabeth in the Tower of London under a sentence of death, and died there ten years later.

It is hardly surprising that the younger Thomas Howard grew up with one overriding ambition: to restore the titles, possessions, and standing of the Howard family, which should by right have placed him as second only to royalty in both status and wealth. The Dukedom of Norfolk in the name of Howard went back to the time of the War of the Roses, when the first duke was killed fighting on Richard III's side at Bosworth Field in 1485. His son, Thomas, the hero of Flodden Field in 1513, was—after a period of family disfavor with the Tudor kings— not only restored to the dukedom but also made a Knight of the Garter and the Earl Marshal. The second duke, according to legend, personally killed King James IV of Scotland. (His sword, helm, and gauntlet were lovingly preserved as family treasures and are prominently displayed in the small painting by Philip Fruytiers of the subject of the Earl of Arundel and his family [FIGURE 4], painted over a century later.) The third duke, known from Holbein's portrait [FIGURE 5], played a powerful if dangerous role under Henry VIII, but since his poet son, the Earl of Surrey [FIGURE 6], was executed before his death, he was succeeded as fourth duke by his grandson, Thomas, the grandfather of the present Thomas.

This personal crusade to try and reestablish the family's rightful position in the aristocracy of the country was, despite a series of reversals, resolutely

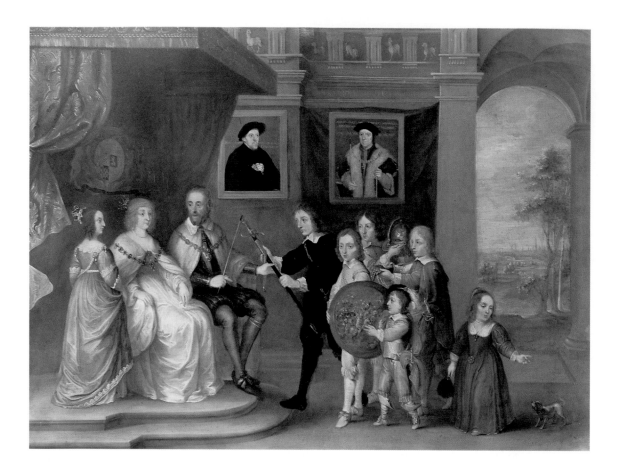

Figure 4
After (?) Philip Fruytiers
(Flemish, 1610–1665).
Thomas Howard,
2nd Earl of Arundel
and His Wife with
Their Grandchildren
and a Dwarf, circa 1643.
Oil on copper, 40.8 ×
55.9 cm (16 × 22 in.).
Arundel Castle,
The Duke of Norfolk.

pursued by Thomas Howard for his entire life. And it was a source of acute dis-appointment that his ultimate goal was not to be achieved until after his death (the dukedom was finally restored to his grandson in 1660). Such single-mindedness undoubtedly determined the course of his life, and already at an early age he became so engrossed in the history of the Howards that it was said of him that he "thought no other part of history considerable but what related to his own family." [3] (In later years he commissioned a richly illuminated book with a family tree [Duke of Norfolk] accompanied by numerous shields and portraits, recording the family history supposedly back to the reign of King Edgar, before the Norman Conquest.) Whether consciously furthering this ambition or merely expressing his character, he adopted a general aloofness to the world, which led

4

to the accusation that he was "a man supercilious and proud, who lived always within himself, conversing little with any who were in common conversation."[4] Even his secretary felt constrained to remark that "He was not popular at all, nor cared for it, as loving better by a just Hand than Flattery to let the common People to know their Distance and due Observance."[5]

Thomas Howard had been born in a simple parsonage in Essex, and because of his father's fate his education had become the responsibility of his mother. She subjected him to an austere and rigid upbringing with strict observance of the Catholic faith, which, for political reasons, he later repudiated in favor of the Church of England. His mother was constantly fearful that her son might attract the disfavor of Queen Elizabeth and kept him out of the public eye. He led a lonely life, which was intensified by the death of his much-loved sis-

Figure 5
Hans Holbein the Younger (German, 1497/8–1543). *Thomas Howard, 3rd Duke of Norfolk (1473–1554),* circa 1539. Oil on panel, 80.6 × 60.9 cm (31¾ × 24 in.). Windsor Castle, H.M. The Queen.

Figure 6
Hans Holbein the Younger. *Henry Howard, Earl of Surrey (circa 1517–1547),* circa 1542. Oil on panel, 55.5 × 44 cm (21⅞ × 1⅜ in.). São Paolo, Museo de Arte.

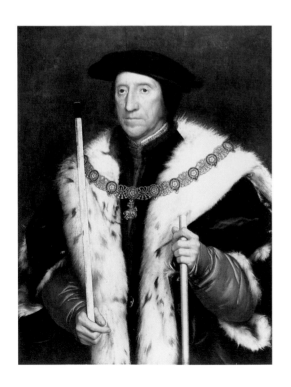

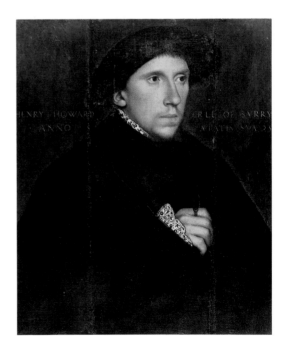

ter when he was only thirteen. The details of his education remain unknown, but extensive reading clearly played an important part, the rewards of which remained with him throughout his life.

When Queen Elizabeth I died in 1603 and was succeeded by James I, Thomas Howard was quick to present himself at court. Since his grandfather had been executed for acting in the cause of the new king's mother, Mary, Queen of Scots, Thomas had expectations that his cause might be favored. But his powerful Howard relatives, notably his great-uncle, the Earl of Northampton, and his step-uncle, the Earl of Suffolk, were no less speedy in presenting themselves, and to Thomas Howard's chagrin were successful in persuading the king to grant them rather than him the confiscated Howard estates. His older cousin, the Earl of Nottingham and Lord Admiral, with no entitlement to the inheritance, was also successful in getting the king to grant him what should of right have been Thomas Howard's home, Arundel House in the Strand. But where titles were concerned he had better fortune, and the earldoms of Arundel and Surrey as well as the various baronies held by his grandfather were restored to him by James I; yet he was not granted the ancient precedence, a matter which was to embitter him for years to come. Although his position at James's court was not invariably easy, he began to make gradual progress toward reaching the status to which he believed his inheritance entitled him.

In 1606 he greatly strengthened his position by marrying Aletheia Talbot, the youngest daughter of the seventh Earl of Shrewsbury, who through her mother was granddaughter of the famous Bess of Hardwick. This marriage brought Arundel both great wealth and a father-in-law who was a powerful and lavish patron of the arts and learning. The earl lived in great splendor in Worksop Manor, one of the great Elizabethan "prodigy houses" created for him by Robert Smythson, and was extravagant in building new houses on his estates in the Midlands. In his youth he had traveled to Italy, visiting Venice in 1576, the year of Titian's death, when Tintoretto, Veronese, and Andrea Palladio were still at the height of their powers. Such an enlightened if tyrannical father-in-law must undoubtedly have had an influence on the young Arundel and set him on the first stage of becoming a great patron of the arts.

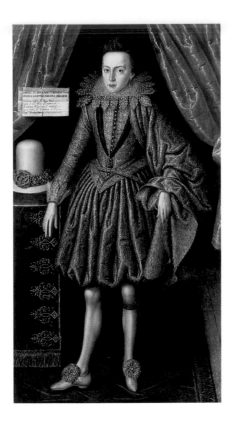

Figure 7
Robert Peake the Elder
(English, fl. 1576–died
1626?). *Charles I as
Prince of Wales
(1600–1649), circa
1612/3.* Oil on canvas,
158.7 × 87.7 cm
(62 ½ × 34 ½ in.).
Cambridge, The University of Cambridge.

In 1611 Arundel made a further advance, when in company with the king's younger son, Charles [FIGURE 7], then Duke of York, he was created a Knight of the Garter. (The Order, an English rival to the Burgundian Golden Fleece, had been upgraded by Elizabeth, who saw it as a means of creating loyal support for the monarch among the highest in rank, and under the Stuarts it continued to be regarded as the prime order of chivalry.) And ten years later, in July 1621, the king, as a token of his continuing favor, permanently confirmed Arundel as Earl Marshal of England. This office, both ceremonial and powerful, had been held by his ancestors from the time of the second duke; from 1616, however, he had been made to share it in commission with five others. This honor entitled Arundel to carry the gold-topped staff engraved with the king's arms as well as his own. Given the prominence of the Garter in Van Dyck's portrait of the earl, we may guess that, had the painting not been finished and the artist departed

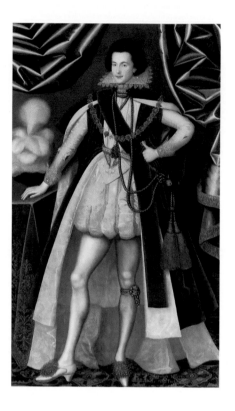

Figure 8
Attributed to William
Larkin (English, fl. 1610–
1620). *George Villiers,
1st Duke of Buckingham
(1592–1628)*, circa
1616. Oil on canvas,
203.7 × 119.5 cm
(81 × 47 in.). London,
National Portrait Gallery
(3840).

from England before Arundel's appointment as Earl Marshal, the golden staff, the symbol of office, would have been included, as it had been so prominently in Holbein's portait of his ancestor [FIGURE 5]. But it is likely that to celebrate his latest appointment Arundel commissioned the lavish illustrated book recording the history of the Earls Marshall of England from the time of King Henry I to that of James I.[6]

 Surrounded by his favorites, James established a court both frivolous and corrupt. When Charles succeeded him, a contemporary wrote how "the fooles and bawds, mimics and catamites of the former court grew out of fashion," and the courtiers no longer indulged in "the bawdry and profane abusive wit which was the only exercise of the other court."[7] James personally had little interest in the visual arts and even disliked the required duty for a monarch of sitting for his portrait. There is no record of him acquiring a single work of art during his

reign. But aware that generous patronage and lively appreciation of the arts was the norm at other European royal courts, he freely encouraged the arts even if he left the act of doing so to those around him. Despite his lack of interest, he reigned over a distinguished era in the arts.

One of the key figures at James's court was George Villiers, later Duke of Buckingham [FIGURE 8], who, after catching the king's eye in 1614, developed into Arundel's great rival both as a collector and a manipulator of political power. By Arundel's aristocratic standards, Buckingham was an upstart, a country gentleman without a title. But he moved up through the ranks of the nobility with astonishing speed; he was created a knight in 1615, Knight of the Garter and viscount in 1616, earl in 1617, marquis in 1618, Lord High Admiral in 1619, and finally duke in 1623. The key to his success was his instinctive knowledge of how to win both James's favor and subsequently that of his younger son and eventual successor. With his easier, more pleasure-loving nature, Buckingham was able to get far closer to his royal patrons than the austere Arundel. And despite the overall improvement in Arundel's position, he had to face a number of what must have been painful slights and disappointments in his relations with his rival, none more so than in 1623 when Buckingham was created a duke. Simultaneously, James had offered the same honor to Arundel, but since it would be a new creation and not the keenly sought restitution of the ancient title attainted by Queen Elizabeth, it was rejected.

Whereas Arundel would not have found the prevailing atmosphere surrounding the king personally agreeable, he was able to turn to the circle surrounding James's consort, Queen Anne [FIGURE 9], for more congenial company. Like her brother, Christian IV of Denmark, who during his reign established Copenhagen as an artistic center, she was passionately committed to the arts. She was the prime mover in reinstituting the royal masque, an art form that gave rise to the brilliant partnership of Ben Jonson and Inigo Jones as writer and designer respectively of a whole series of spectacular performances. And, as is illustrated by a drawing of the Countess of Arundel's costume for *The Masque of Queens* [FIGURE 10], performed in 1609, these were occasions in which Arundel and his wife actively participated. The queen was no less interested in painting, and she actively acquired not only portraits of family and ancestors but also subject pic-

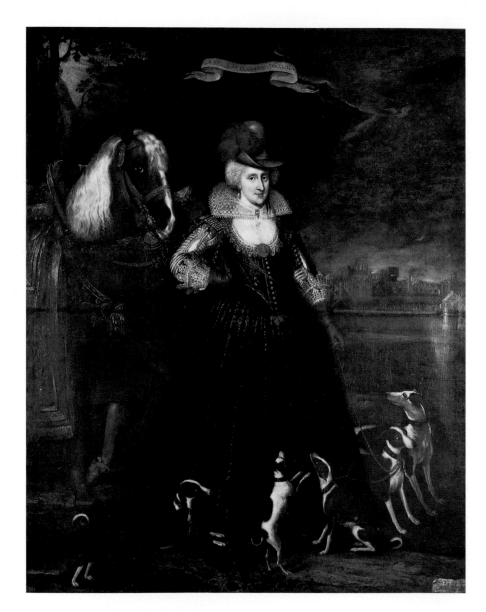

Figure 9
Paul van Somer (Flemish, circa 1576–circa 1621/2). *Queen Anne of Denmark (1574–1619)*, 1617. Oil on canvas, 233.7 × 147.6 cm (92 × 58½ in.). Windsor Castle, H.M. The Queen.

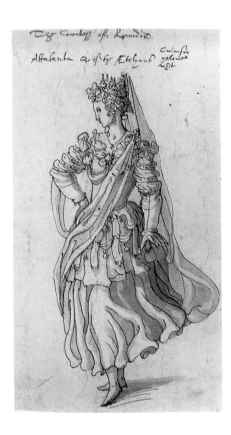

Figure 10

Inigo Jones (English, 1573–1652). *Atalanta* (Lady Arundel's costume for *The Masque of Queens*), 1609. Pen and brown ink with gray wash, 27.7 × 15.4 cm (10⅞ × 6 in.). Chatsworth, Devonshire Collection.

tures—religious, mythological, still-life, and topographical—which decorated her London residence, Somerset House, situated next door to Arundel House in the Strand, as well as her palaces at Greenwich and Oatlands. She was reported by Lord Salisbury, a member of the queen's circle, who was courted and advised in artistic matters by the young Arundel, to have preferred pictures to people, and according to George Abbot, the Archbishop of Canterbury, on the day before she died she visited her gallery to look at her pictures. She regarded Arundel with favor and as a token of her esteem she offered to become godmother to the Arundel's son and heir.[8]

Queen Anne undoubtedly played an influential role in establishing the taste of her elder son, Henry [FIGURE 11], who died so tragically at the age of eighteen in 1612, only two years after he had been created Prince of Wales. Already by the end of 1609 Henry was busy assembling his own household, and it

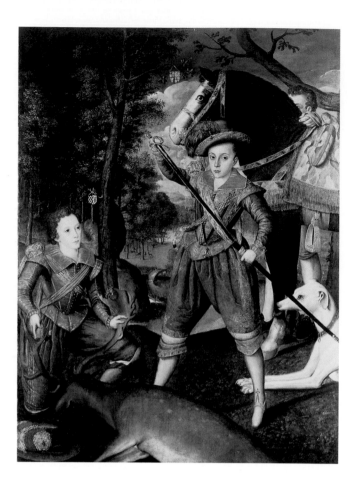

Figure 11
Robert Peake the Elder.
*Henry, Prince of Wales
(1594–1612) with John,
2nd Lord Harington
of Exton (1592–1614),*
1603. Oil on canvas,
203.3 × 147.4 cm
(79 ½ × 58 in.).
New York, Metropolitan
Museum of Art (44.27).

is hardly surprising that the Earl of Arundel was prominent among the members of the new court. As his son was later to claim, Arundel "was most particularly favored" by Henry, who "was known to value none but extraordinary persons,"[9] an assessment borne out by the names of those surrounding him, men of action as well as the earliest connoisseurs and collectors. Apart from sharing a taste for taking part in masques, tilts, pageants, and other entertainments, and for hunting—they first performed together in the pageant known as "Prince Henry's Barriers" [FIGURE 12], designed by Inigo Jones to celebrate Henry's investiture as Prince of Wales in 1610—Arundel was regarded by Henry as a trusted adviser on the merits of works of art. In 1610 Lord Salisbury was informed that if he was unable to pre-

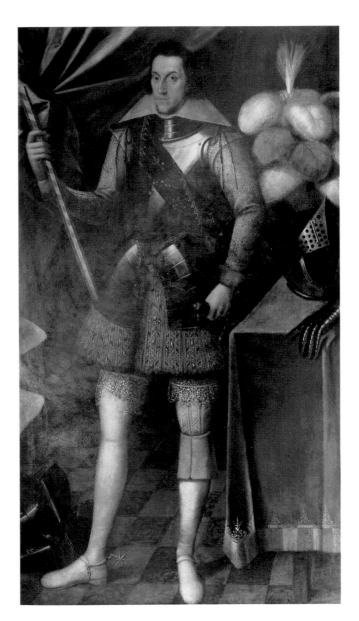

sent himself with his pictures before the prince, he "may send my Lord of Arundel as deputy to set forth the praise of your pictures."[10] And when Arundel was traveling abroad seeking a cure to his ill health, the prince, "lying on his death bed, would divers times say that he prayed to God to send back Arundel with perfect health, which was a great expression of how much he valued that person."[11] The two men shared a relationship which Arundel was never later able to realize, for all the genuine attempts on both sides, with Henry's younger brother, Charles, when he eventually came to the throne.

In 1612, threatened with consumption, Arundel had been granted permission to travel abroad to take the waters. He first went to Spa in Belgium and subsequently to Padua, from where he visited Venice. This journey was important for inspiring Arundel with a love of Italy, and particularly for Venetian painting, which was to form a central part of his collection. The English ambassador in Venice at the time, Sir Dudley Carleton, was told by his agent that Arundel "liketh Italy so well that I believe your Lordship is like to see him once more there before your departure from thence."[12]

This journey also gave him his first knowledge of Flemish painting. Visiting Brussels and Antwerp on his way to Spa, he proved an indefatigable sightseer. In the former he visited the Duke of Aerschot's gallery—his English guide on that occasion later recalled "the great love and affection which your Honour beareth to the mystery of painting."[13] From Antwerp, Arundel wrote appreciatively of the services of the resident agent, who "hath let me want the sight of no curiosity, which either his pains or acquaintance could help me to."[14] He also came into contact with the Antwerp painter Hendrick van Balen, and both men went to admire the celebrated picture of *Ferry Carondolet and Attendants* (Thyssen-Bornemisza collection) by Sebastiano del Piombo, which Arundel believed was by Raphael. Although Van Balen was a collaborator of Rubens, and the artistic community of Antwerp was relatively small, there is, regrettably, no indication whether Arundel met Rubens or any other painter, such as the young Van Dyck, who three years earlier had been accepted by Van Balen as an apprentice. But given his interest in art, it seems plausible that Arundel would at least have attempted to meet Rubens, who had already emerged as the leading painter in the city and was being referred to as "the god of painters."[15]

Figure 13
Francesco Villamena
(Italian, 1566–1624).
Inigo Jones, circa 1614.
Engraving, 25.2 ×
19.2 cm (10 × 7 ½ in.).
Oxford, Ashmolean
Museum, Hope
Collection.

From an artistic point of view, the most important person at Prince Henry's court was Inigo Jones [FIGURE 13], who, despite never having designed a building, was appointed as the prince's surveyor in 1610. Jones was already well known to Henry as a designer of masques and festivals, which played such an important part of life at the Stuart court, and it may have been through such work that he met Arundel, an event which must have taken place by 1606, when the earl performed in a masque designed by Jones. But the close association between Arundel and Jones only developed the year after the prince's death, when both men were members of the party sent to accompany Henry's sister, Elizabeth, and her new husband, Frederick V, the Elector Palatine of the Rhine, to Heidelberg. From there the two men went on to Italy for what was to be an entirely educational experience, lasting eighteen months. For both it was their second visit, and Arundel, who was fulfilling the prophecy of Carleton's agent, had discovered in Inigo Jones the ideal learned companion, who was as interested in antiquity and sixteenth-century Italian art as he was in immersing himself in a study of architecture, both ancient and modern, in preparation for his new profession.

Arriving in Milan in the summer of 1613, they visited Venice, Vicenza, Padua, Florence, and Siena, before finally reaching Rome in January 1614. Owing

to the continuing hostility between the English monarchy and the papacy, there were diplomatic frissons in London when it was learned that Arundel, still a Roman Catholic, insisted on going to Rome, a city that had been expressly forbidden to English travelers. Undoubtedly Arundel's first visit to the *caput mundi* lived up to expectations and he succinctly expressed his feelings to his wife: "I would wish you to see Rome well, for there are no more such places."[16] From there the party, which by this time included the Countess of Arundel, went south to Naples. Returning north to Padua in July 1614, Arundel received the news of the death of his great-uncle, the Earl of Northampton, who had bequeathed him a magnificent house and accompanying land at Greenwich, and he was forced to cut short his visit.

For someone brought up in the reign of Queen Elizabeth, traveling on the Continent was a new experience, and in making what was to become known as the Grand Tour, Arundel was establishing a pattern of behavior which was to have an immense influence on the arts in England. He was the first English nobleman to visit Italy with the prime intention of studying the art and architecture. As Sir Edward Walker was to write, Arundel "was the only great subject of the northern parts who set a value upon that country."[17] And the experience of Italy confirmed Arundel as an Italophile, a fact which was to influence both his attitudes and his activities for the remainder of his life, above all in his patronage of the arts.

Apart from carrying out an excavation in Rome, Arundel almost certainly began to collect Greek and Roman sculpture, possibly on the advice of Inigo Jones.[18] One of his first likely acquisitions was the marble statue of Homerus [FIGURE 14], which Rubens had copied [FIGURE 15] some years earlier, recording it in a far less damaged state than today. The piece can be seen in the center of the wall in the portrait of Arundel by Mytens [FIGURE 16]. It may also have been in Italy that Arundel developed his passion for collecting drawings by Parmigianino, an artist to whose works he may well have been introduced by Inigo Jones.[19] Probably in the Veneto, Arundel and Jones were able to acquire a large group of drawings by Scamozzi and Palladio; at his death Arundel left "two chests with architectural designs by Vincenzo Scamozzi."[20]

Inigo Jones continued to play an advisory role to Arundel after their return from Italy, but Arundel's circle consisted of other learned figures, such as

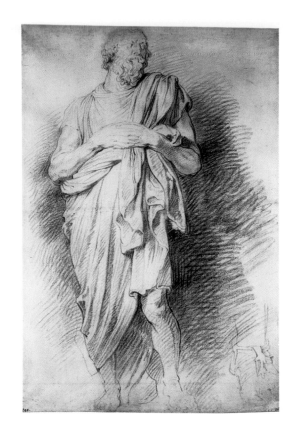

Sir Robert Cotton (1571–1631), the scholar and antiquarian and owner of a celebrated library, who was described by Rubens as "a great antiquarian, versed in various sciences and branches of learning."[21] As we learn from a letter written by Arundel in 1613, he had commissioned Cotton to write a history celebrating the greatness of his ancestors. John Selden (1584–1654), a celebrated lawyer and scholar, was a close friend who catalogued the collection of classical inscriptions at Arundel House, published in 1628 under the title *Marmora Arundelliana*. As well as being the first archaeological study written by an Englishman, the book made Arundel's collection known to scholars throughout Europe, including Rubens, who enthusiastically referred to this volume. Sir William Dugdale (1605–1686), one of the most famous antiquarians of the time, best known for his three-volume *Monasticon*, containing a history of ancient religious foundations in

Figure 14
Hellenistic (circa second century, B.C.). *Homerus*. Marble, H: 185 cm (72⅜ in.). Oxford, Ashmolean Museum (1984.45).

Figure 15
Peter Paul Rubens (Flemish, 1577–1640). Copy after the *Homerus*, circa 1606/8. Black chalk, 55.2 × 36.1 cm (21¾ × 14½ in.). Berlin, Staatliche Museen, Kupferstichkabinett KdZ (10601).

England, was a protégé of Arundel, who encouraged him to use his library for research as well as giving him an appointment at the College of Arms.

In the 1630s Arundel employed the distinguished Dutch scholar Francis Junius as his librarian, encouraging him to write his magnum opus, *De pictura veterum* (1637), which, at the countess's instigation, was translated into English and published with a dedication to her the following year. And in 1636, as part of his scholarly intentions, Arundel was responsible for bringing the Czech artist, Wenceslaus Hollar, to England and taking him into his service. Hollar, who had started his service for Arundel by making watercolor drawings of the embassy to the emperor, went on to produce etchings after old-master drawings in the earl's collection, conceivably with a companion volume to Selden's on the marbles in mind, as well as views of his residences. While the taste for the visual arts was rapidly developing among various members of the English court, the scholarly atmosphere created around Arundel was unique, and it distinguished him from other great contemporary collectors.

Arundel House in the Strand, which to Arundel's dismay had been given by James I at the beginning of his reign to Charles Howard, Earl of Nottingham, was finally restored to him as the rightful owner in 1607, but only after Arundel, to his great annoyance, had been forced to pay a heavy bribe to his elderly cousin to move out. After his return from Italy in 1614 he proceeded, with Inigo Jones as his architect, to make some additions and alterations, although there are few records connected with this work. It seems likely, however, that the architect was responsible for adding the two-story wing, built in brick with stone dressings, which ran south from the main house down to the river Thames. The exterior of this building with its flat roof [FIGURE 17], severely classical in style, makes a striking contrast to the richly molded Tudor exterior of the old house.

The new wing almost certainly housed the sculpture and picture galleries which the Arundels added and which seemingly appear in the backgrounds to the full-length portraits of the earl and countess painted by Daniel Mytens probably by 1618. Behind the earl [FIGURE 16], a barrel-vaulted room on the first floor, with a view of the river, contains many classical sculptures, including *Homerus* [FIGURE 14], while on the ground floor below, the countess [FIGURE 18] is seated before a flat-roofed room with a simply designed plaster ceiling; full-length

Figure 16
Daniel Mytens (Dutch, circa 1590–1647). *Thomas Howard, 2nd Earl of Arundel,* circa 1618. Oil on canvas, 214.6 × 133.4 cm (84½ × 52½ in.). Arundel Castle, The Duke of Norfolk.

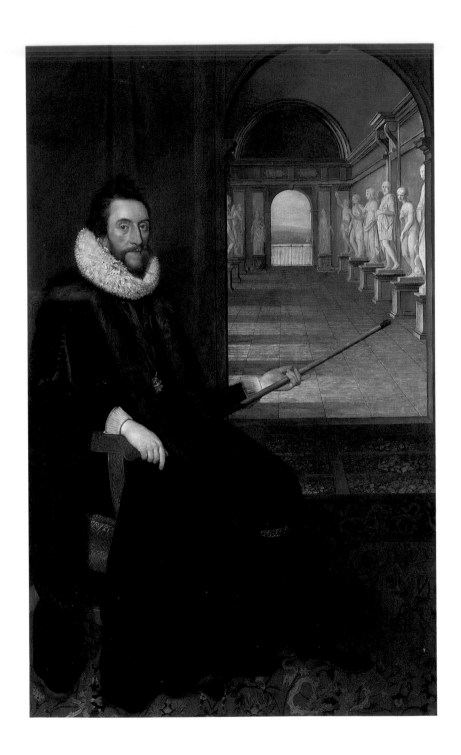

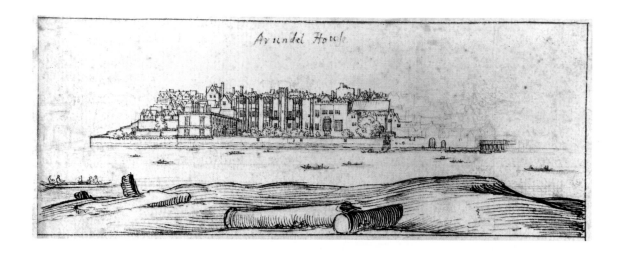

portraits fill the spaces between the windows, with smaller pictures hung in the embrasures and further portraits on either side of the door at the end of the gallery. Unlike the richly cluttered hang of Tudor and other Jacobean galleries, the effect is simple and severe. But if the detail of the interior decoration in these two pictures is almost certainly imaginary, the general appearance must, in view of Arundel's known satisfaction with the pictures, be a clear reflection of the classical style he favored.[22]

These meager visual records of the setting for a great collection of works of art can be amplified by contemporary descriptions. The new wing must have been finished by 1627 when the German painter and writer, Joachim von Sandrart, visited the house: "Foremost among the objects worthy to be seen, stood the beautiful garden of that most famous lover of art, the Earl of Arundel; resplendent with the finest ancient statues in marble, of Greek and Roman workmanship . . . From the garden one passed into the long gallery of the house; where the superlative excellence of the works of Hans Holbein of Basel, held the master's place . . . Other portraits were there also; some by old German and Dutch masters; some by Raphael of Urbino, by Leonardo da Vinci, by Titian, Tintoretto, and Paolo Veronese."[23] Henry Peacham, describing the classical inscriptions, says that "You shall find all the walls of the house inlaid with them and speaking Greek and Latin to you. The garden especially will afford you the plea-

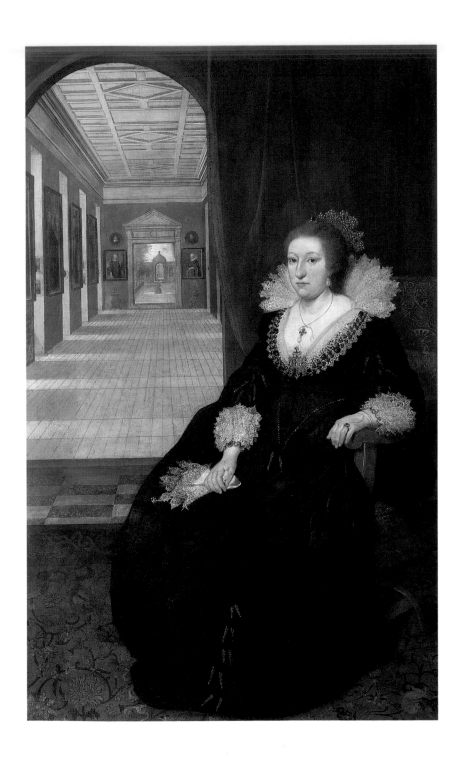

sure of a world of learned lectures in this kind."[24] But the most colorful account of the collection was given by Sir Francis Bacon, who "coming into the Earl of Arundel's Garden, where there were a great number of Ancient statues of naked Men and Women, made stand, and as astonish'd cryed out: *The Resurrection*."[25] The garden adorned with classical sculpture which so impressed visitors was new to contemporary taste and reflected what Arundel had seen in Italy.

Today it is impossible to reconstruct the contents of his collection or determine when the different parts were acquired. If much was certainly only added after the date of Van Dyck's first portrait of Arundel, the desire to collect was already there and a serious start had been made. At some point he gained possession of part of his family collection, including some of the greatest paintings by Holbein, which had passed from an earlier Earl of Arundel, Henry Fitzalan, to Lord Lumley, the present earl's great-uncle, who died in 1609. In 1616 he acquired a number of paintings, some as a gift from James I and others from Sir Dudley Carleton, from the collection of pictures belonging to the disgraced Earl of Somerset.

In addition to the classical antiquities which Arundel bought himself in Italy, the collection would have included by the time of Van Dyck's arrival Lord Roos's gift of "all the statues he brought out of Italy at one clap," which "exceedingly beautified his Lordship's Gallery."[26] In the same year (1616) Sir Dudley Carleton, by that time ambassador in The Hague, gave a sculpted head of Jupiter to Arundel, who strikingly sited it, no doubt recalling what he had seen in Italy, "in his utmost garden, so opposite to the Gallery doors, as being open, so soon as you enter into the front Garden you have the head in your eye all the way."[27]

Like many a dedicated collector, he was, once he had conceived the desire for an object, a determined and unscrupulous acquisitor, put off neither by cost—his debt after his death amounted to over £100,000—nor by rivals. In 1618 the Countess of Bedford spoke bitterly of "a tricke my Lo. of Arundell putt upon me yesterday to the cusning [*sic*] me of some pictures promised me."[28] In 1621, the year that Van Dyck came to England, Sir Thomas Roe was sent as ambassador to Constantinople and at the same time was commissioned by Arundel to act as his agent in Greece and Turkey for finding antiquities. And his successor in this role, William Petty, the earl's chaplain, displayed a ruthless touch in 1624 or 1625,

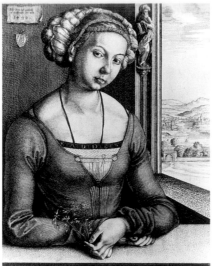

ILLVSTRISSIMÆ. ET EXCELLENTISSIMÆ. DÑE. DOMINA. ALATHEÆ. TAL-
lost. Arundeliæ. & Surriæ. Comitissæ, &c: hanc tabellam olim ab Alberto Durero ad viuum depic-
tam, jamq in Collectione Arundeliana conseruatam, & a Wenceslao Hollar Bohemo Aqua forti æri
insculptam, humillime offert et dedicat. Adam Alexius Bierling. Antuerpiæ Anno 1646

Figure 19
Wenceslaus Hollar after
Albrecht Dürer (German,
1471–1528). *Katharina
Frey (circa 1478/9–
1547)*, 1646. Etching,
23.6 × 17.5 cm
(9 ½ × 6 ⅞ in.). Oxford,
Ashmolean Museum.

as Peiresc's agent found to his cost, when wrongfully imprisoned on a trumped-up charge in Smyrna, he lost, before he could extricate himself from jail, a large group of Greek inscriptions, including the *Parian Marble* (Ashmolean Museum, Oxford) to his English rival.[29]

By the time of Arundel's final departure from England at the beginning of the Civil War, his collection must have been a most impressive assembly of paintings, drawings, sculpture, books, and prints. An inventory of pictures and works of art drawn up in Amsterdam in 1655 after the countess's death lists 799 works, over half of which were paintings listed under the names of specific artists; connoisseurship was then in its infancy, so the attributions need to be treated with considerable scepticism, in many cases probably referring to copies rather than originals. Compared with his contemporary English collectors, he displayed an unusual taste for the art of northern Europe. He had a particular passion for the works of Dürer, by whom sixteen paintings and watercolors are listed in the inventory; from reproductive etchings by Hollar, we know that he owned the charming, early *Portrait of Katharina Frey*, holding two flowers symbolic of love, which was recorded in his possession by Hollar [FIGURE 19].

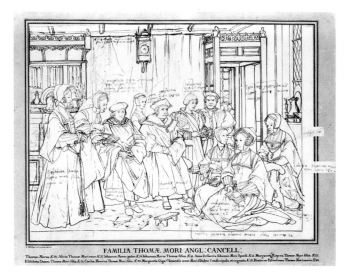

Figure 20
Hans Holbein the
Younger. *The Family of
Sir Thomas More
(1478–1535),* circa
1530. Pen and black ink,
38.8 × 52.4 cm (15½ ×
20⅝ in.). Basel,
Öffentliche Kunstsamm-
lung, Kupferstichkabinett
(1662.31).

Hans Holbein the Younger was no less a favorite with Arundel. "My
foolish curiosity in enquiring for the pieces of Holbein"[30] was clearly inspired
by the important group of pictures by the artist, obtained from the widow of
his great-uncle Lord Lumley, which included such major works as the portraits
of Christina of Denmark (National Gallery, London) and Sir Henry Guildford
(H.M. The Queen), as well as the family portraits of the third Duke of Norfolk
[FIGURE 5] and the poet Earl of Surrey [FIGURE 6]. To these were added many
other masterpieces such as the portrait of William Wareham, Archbishop of Can-
terbury (Louvre, Paris), the great composition of Sir Thomas More surrounded
by his family [FIGURE 20], and the decorations from the German steelyard in
Blackfriars illustrating the *Triumph of Poverty* and the *Triumph of Riches* (all
three of which were destroyed by fire in 1752). The inventory of the collection
drawn up after his death lists no less than forty-four works by Holbein. In addi-
tion he owned the "great Booke of Pictures [i.e., drawings] doone by Haunce
Holbyn of certyne Lordes, Ladyes, gentlemen and gentlewomen of King Henry
the 8 his tyme" (now forming the unique collection of the artist's drawings at
Windsor Castle), which he was given by his brother-in-law, the Earl of Pembroke,
who had received the volume from Charles I in an exchange for a painting by
Raphael. Nearer to his own time, Arundel admired the art of Adam Elsheimer, pos-

sibly owning the famous polyptych of the *Finding of the True Cross* (Städelsches Kunstinstitut, Frankfurt).

From the Italian school, he supposedly owned twelve paintings by Correggio and the same number of works by Raphael, including drawings, and twenty-six works by Parmigianino, including two watercolors(!). But the largest group listed in the inventory were the paintings by Venetian artists, reflecting the predominant taste of the English court, with thirty-seven by Titian, including either the originals or versions of the *Flaying of Marsyas* (Kromeriz Museum) and the *Three Ages of Man* [FIGURE 21], and substantial groups by Giorgione, Tintoretto, Veronese, and Bassano. Although some drawings were listed and can be

Figure 21
Titian (Italian, before 1511–1576). *The Three Ages of Man*, circa 1512–15. Oil on canvas, 106.7 × 182.9 cm (42 × 72 in.). Edinburgh, National Gallery of Scotland (on loan from the Duke of Sutherland).

25

Figure 22
Roman (early first century, A.D.). The *Felix Gem*. Carnelian, 2.7 × 3.4 cm (1⅛ × 1⅜ in.). Oxford, Ashmolean Museum (1966.1808).

identified, such as the famous album of studies by Leonardo da Vinci (Windsor Castle) acquired by 1627, and others recorded in Hollar's etchings, there were clearly very many more. If the collection belonging to Arundel's son, William Howard, Lord Stafford, was wholly or largely inherited from his father, we can gain some notion of the sheer quantity from what was sold in 1720, namely two hundred pictures, over two thousand drawings, and over six thousand prints.

With its substantial library of books and manuscripts, including a part of the celebrated Pirckheimer collection of manuscripts and incunabula acquired in Nuremberg in 1636; the assembly of classical sculpture and inscriptions, which by the late 1630s numbered 37 statues, 128 busts, 250 inscriptions, many sarcophagi, altars and fragments, and an extensive gem cabinet, which included such works as the precious Felix Gem [FIGURE 22], the collection was more didactic in character than those created by those other two great collectors of the time, Charles I and the Duke of Buckingham. The latter, we are told, "was not so fond of antiquity to court it in a deformed or mishapen stone,"[31] and his taste probably reflected what his agent, Gerbier, told him, namely that "pictures are noble ornaments, a delightful amusement, and histories that one may read without fatigue."[32] At least part of Arundel's collection had a more historical purpose, since like his great French antiquarian contemporary, Nicolas-Claude Fabri de Peiresc, he sought to re-create the classical past through a study of its artifacts, fragments,

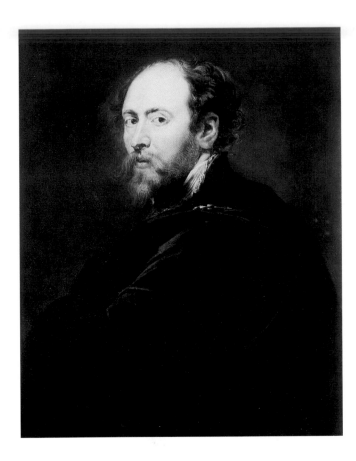

and inscriptions. He conceived his collection as being more than an assembly of beautiful or interesting objects; it possessed a moral virtue from which the viewer could learn. He was, what Horace Walpole was so memorably to call him, "the father of *virtù*" in England.

Arundel was widely recognized as being a discerning patron of living artists as well as an outstanding collector of the past, an unusual combination of activities which was to be found in other English figures of the period. Rubens [FIGURE 23], who in 1620 had been commissioned to paint the countess's portrait, memorably spoke of "holding him for one of the four evangelists, and a supporter of our art,"[33] while Arundel's son, William Howard, Viscount Stafford, described Arundel as "one that Loved and favored all artes and artists in a greate measure,

and was a bringer of them in to Englande."[34] Both Mytens and Van Dyck more or less, as will be examined, owed their invitations to come and work in England to the earl. Later on Wenceslaus Hollar, as already mentioned, was to be taken into his service as an etcher and draftsman, and in the same year (1636) the Flemish sculptor, François Dieussart, appears to have been brought from Rome by the earl. And it was his intention, as expressed in his will, that the Florentine sculptor Francesco Fanelli, then resident in England, should design his tomb.

In addition to his great interest and taste in the visual arts, Arundel is remarkable for the fact that his assessment of artists was based on his ability to react as a well-informed and intelligent critic of painting, as he demonstrated, for example, when assessing the gift of a picture, *Aeneas Fleeing from Troy* (now lost) by the Utrecht artist, Gerrit van Honthorst: "I think the painter has expressed the story with much art, and both for the postures and the colouring I have seen few Dutch men arrive unto it; for it has more of the Italian than the Flemish and much of the manner of Caravaggio's colouring, which is now so much esteemed in Rome," and which Arundel had seen for himself.[35] This judgment represents a piece of connoisseurship of which no student today need feel ashamed.

As an accompaniment to such rich and varied possessions, it is appropriate that Arundel created an equivalent "life-style." As his secretary wrote, "He was . . . sumptuous in his Plate and Housholdstuff, and full of State and Magnificence in his Entertainments, especially of Strangers, and at his table very free and pleasant."[36] When Van Dyck arrived in England for the first time, Arundel would undoubtedly have impressed the young artist as an important and rewarding patron to cultivate, and the portrait commission he received brought him into contact with the most distinguished sitter who had so far come his way, and who was only to be surpassed by the future king of England. A self-portrait [FRONTISPIECE] of the time, depicting an elegant young man with romantically fresh looks set off by the self-conscious gestures of his hands, suggests that Van Dyck would have fitted gracefully into English court society.

THE ARTIST IN ANTWERP

Van Dyck was twenty-two when he painted his first portrait of the Earl of Arundel [FIGURES 1–3] and he had reached a critical stage in his career. He had established himself as an independent painter with his own studio and, although he had only just left Antwerp for the first time, his popularity both at home and abroad was rapidly growing. But for someone as ambitious and able as Van Dyck, there was an insurmountable obstacle to his further progress in Antwerp. Peter Paul Rubens [FIGURE 23], twenty-two years older, was incontestably established as the principal painter in the southern Netherlands, and his international reputation was growing immeasurably, with both the English and French courts poised to attract his services for major commissions.

Van Dyck had been born on March 22, 1599 in the house "Den Berendans" ("The Bears' Dance") on the Grote Markt in Antwerp, the seventh child of a wealthy merchant. The family was very religious; three of his sisters became nuns and his youngest brother a priest. Anthony, like his father before him, joined a religious confraternity in Antwerp.

We know remarkably little about his early years.[37] His father's business traded successfully in silk, linen, wool, and other fabrics and was active in Paris, London, and Cologne, as well as in his native Antwerp, although by 1615 he was in financial difficulties. His mother, Maria Cuypers, who was renowned for the beauty of her embroidery, died when he was eight. Two years later in 1609 he was enrolled in the Antwerp Guild of Saint Luke as a pupil of the painter Hendrick van Balen. Apart from appearing as a petitioner in a legal dispute regarding his grandmother's estate, there are few other records until on February 11, 1618 he was received into the Antwerp Guild as a master and four days later was deemed, with his father's approval, to have come of age. From then until his departure to England in 1620, there are only three or probably four references to him, all in connection with Rubens, one of which is a valuable account of the young artist in a letter written to the Earl of Arundel. At some point during the

decade he appears to have set up as an independent painter in his own rented studio in a house called "den Dom van Ceulen" (the cathedral of Cologne), where he painted a series of apostles. According to much later legal testimony, this happened about 1615 or 1616, which would have indicated that he was unusually, perhaps under Rubens's protection, earning his living as a painter before he had been accepted as a master of the guild.

There were family reasons for Van Dyck to have chosen to become a painter. His paternal grandfather was a painter before becoming a merchant and his mother was related to a painter, so that he clearly faced no opposition in pursuing this career once he made his intentions known. Hendrick van Balen, who became dean of the artist's guild in the year that Van Dyck was enrolled as his pupil, was a successful local figure painter who was born in Antwerp probably in 1575. His master remains unknown, but he spent ten years in Italy, where he assiduously studied the work of Michelangelo and Raphael before returning home to become a member of the guild in 1593. Van Balen often collaborated with landscape or still-life painters, to whose contributions he would add the figures, painted in a conservative Italianate style [FIGURE 24], of which the best-known exponent in Antwerp was Otto van Veen. He was a popular master who accepted five other pupils in the same year that he received Van Dyck. But apart from learning the basic techniques and practice of painting—grinding pigments and preparing panels and canvases—Van Dyck appears from his known early works to have been little indebted to Van Balen.

For an artist, Antwerp in the second decade of the seventeenth century was a rewarding center in which to practice. Despite the revival of the textile industry, the economic situation of the city remained poor; much of this was due to the continuing control of the Scheldt by the Dutch, who by levying customs duties could adversely affect trade. But, notwithstanding the city's inability to recapture from Amsterdam its position as the principal port in northern Europe, there was sufficient money, combined with the corporate will to commission a large number of religious paintings as part of the refurbishment of existing churches damaged during the iconoclastic riots in the previous century, and the building of new churches. And by good fortune the right person to lead this renaissance of the city appeared at the right time. Peter Paul Rubens, born in

Figure 24
Hendrick van Balen the Elder (Flemish, 1575?–1632) and a follower of Jan Brueghel the Elder (Flemish, 1568–1625). *Pan Pursuing Syrinx*, circa 1615. Oil on copper, 25 × 19.4 cm (9¾ × 7⅝ in.). London, National Gallery (659). Photo: Alinari/Art Resource, New York.

1577, had gone to Italy in 1600 where, besides completing his artistic education by studying the art of the past and the present, he had begun to establish a successful practice as a painter of altarpieces. His mother's death in 1608, however, brought him home sooner than he intended, and after an agonized debate whether to return to Italy, he finally decided to remain in Antwerp and establish his studio in the very year that Van Dyck was apprenticed to Van Balen. Rubens quickly established his supreme unrivaled position among his contemporaries, and although there was a considerable amount of work for other artists, some of it, as we shall see, was in areas which did not interest Rubens. He was soon attracting the major commissions in the city and was in the happy position of choosing what he wanted and on his terms.

In terms of style it was difficult for an artist to escape the effects of the towering position of Rubens, whose influence was further disseminated through the thriving studio practice he was forced to build up in order to cope with the increasing number of commissions from both home and abroad. And in Rubens's new studio, built beside his house on the Wapper, he also employed a number of younger artists, of whom Van Dyck was to become one. These disciples would not only have learned about the practice of painting, but would have had access to the master's growing collections of art, antiquities, and learned books. But in addition to works produced under his direct supervision by young assistants, Rubens, following local custom, often collaborated with older independent artists, specializing in landscape or animal or flower painting, to which he would contribute, as Van Balen was also doing, the figures. His control and influence over the production of art in Antwerp was overwhelming.

For a young, ambitious artist, which Van Dyck unquestionably was, Rubens was a star to emulate, both for his artistic preeminence and for the concomitant worldly success. His rapidly increasing income allowed Rubens, installed in his substantial house on a prosperous street, to assume the manner of living more redolent of a prince than a painter. In 1628 the English diplomat, Sir Thomas Roe, who had served as Arundel's none-too-scrupulous agent in the Near East, met Rubens in Antwerp, "where he had grown so rich by his profession that he appeared everywhere, not like a painter but a great cavalier with a very stately train of servants, horses, coaches, liveries and so forth."[38] And assuming that Rubens was already able to adopt something of this life-style in the 1610s, his example would have attracted Van Dyck, who with his inherited wealth (at least until 1615) was easily able to emulate it. When the latter, still a young man, reached Rome (shortly after his first visit to England), Bellori described how "his manners were more those of an aristocrat than a common man, and he was conspicuous for the richness of his dress and the distinction of his appearance, having been accustomed to consort with noblemen while a pupil of Rubens; and being naturally elegant and eager to make a name for himself, he would wear fine fabrics, hats with feathers and bands, and chains of gold accross his chest, and he maintained a retinue of servants."[39] Bellori goes on to explain how Van Dyck's grand airs and unwillingness to participate in student camaraderie alienated his

fellow Flemish painters also completing their artistic education.

In understanding Van Dyck's mercurial development as an artist, the crucial question depends on the precise nature of his relationship to Rubens, which was already discussed by two seventeenth-century biographers.[40] André Félibien writes that, working in Van Balen's studio, "Van Dyck, who had an extreme passion for learning, lost no time in advancing in knowledge and in the practice of painting. Before long he had surpassed all of the young people who worked with him. But as he had heard much about Rubens and had admired his works, he arranged through friends for Rubens to take him into the studio. This excellent man, who saw right away that Van Dyck had a beautiful talent for painting, conceived a particular affection for him and took much care to instruct him."[41]

Bellori takes the story on, when he writes that Rubens, "liking the good manners of the young man and his grace in drawing, considered himself very fortunate to have found so apt a pupil, who knew how to translate his compositions into drawings from which they could be engraved. . . . Rubens gained no less profit from Van Dyck in painting, since, being unable to fulfill the great number of his commissions, he employed Anthony as a copyist and set him to work directly on his own canvases, to sketch out and even execute his designs in paint. . . . It is said that in this way Rubens' business prospered, . . . while Anthony profited still more from his master, who was a veritable treasury of artistic skills."[42]

It is, however, more difficult to put flesh on the bare bones of this relationship. Today a number of highly finished drawings made for reproductive engravings after Rubens exist, but it remains debatable whether any of them are in fact by Van Dyck.[43] In 1618, in the year that Van Dyck became an independent master, he was almost certainly helping Rubens to prepare the cartoons for what was to be his first tapestry series (now lost), devoted to the story of the Roman consul Decius Mus. Bellori specifically says that "the cartoons and painted pictures" (Liechtenstein collection, Vaduz) for this series was made by Van Dyck, presumably from Rubens's *modelli,* although Rubens, in a letter to Sir Dudley Carleton in May of that year, wrote that he himself had just finished the cartoons for the series. Whatever the truth of the matter (the pictures appear to be the product of more than one hand), there seems no reason to doubt that Van Dyck

was involved in some capacity in this major project, on which considerable studio assistance was undoubtedly required.[44] Further likely evidence of this association occurs in another letter of April 1618 to Carleton from Rubens, who speaks of a painting, *Achilles and the Daughters of Lycomedes* (Museo del Prado, Madrid), "done by the best of my pupils," who is usually taken to be Van Dyck, "and the whole retouched by my hand." The artist adds that it is "a most delightful picture, full of very many beautiful young girls."[45]

In July 1620 the Earl of Arundel received a letter from Antwerp almost certainly written by his Italian secretary, Francesco Vercellini, reporting that "Van Dyck is still with Signor Rubens, and his works are hardly less esteemed than those of his master."[46] (This important letter will be referred to again.) What Van Dyck was principally doing for Rubens can be determined from the contract which the latter signed with the Jesuits four months earlier. This was for the first of the great series of decorations which Rubens produced during his career. With the aid of his studio he was called upon to produce no fewer than thirty-nine ceiling paintings to decorate the Jesuits' newly built church of Saint Charles Borromeo in Antwerp, a church for which he had already produced designs for sculptural decoration and painted two large altarpieces. It was not only a massive task but one which had to be carried out within less than a year from the signing of the contract. Rubens was required to design all thirty-nine subjects, which were to be executed from his *modelli* by Van Dyck and other studio assistants. Rubens would then add the finishing touches as necessary. Van Dyck was in addition required to execute a painting for one of the side altars at a later date (which he never did). Although both Rubens and Van Dyck were extremely fast workers, it remains uncertain as to how far Van Dyck justified his special mention as the only named assistant in the contract, since within five months he had departed for London, not to return until after the commission was finished.[47]

But it is very possible that Van Dyck's association with Rubens went back to an earlier date, perhaps shortly after the former left the studio of Van Balen in 1613. In view of Van Dyck's promise, Rubens may have taken him under his wing about the time that the former was painting his series of apostles in Den Dom van Ceulen. There was certainly contact between the two artists at this time, since a portrait by Rubens of the youthful Van Dyck [FIGURE 25], stylishly dressed

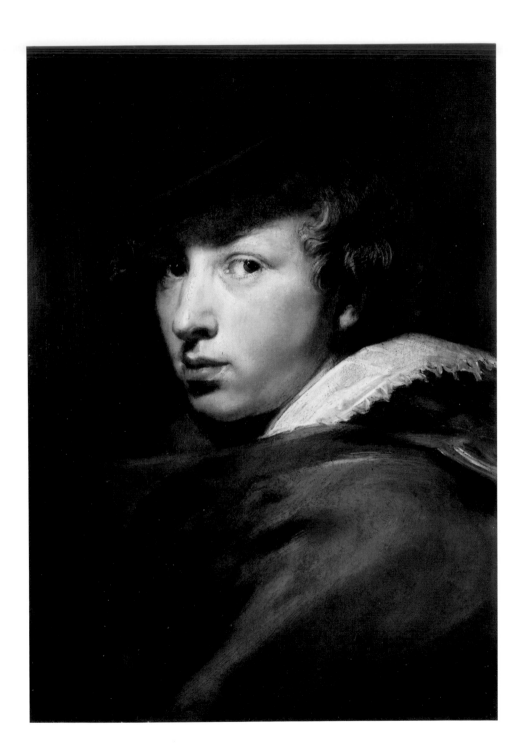

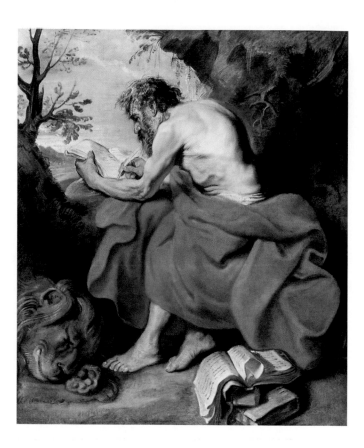

in an ample gray cloak with white lace collar loosely wrapped around the shoulders, was probably painted in the middle of the second decade, when the sitter was fifteen or sixteen.[48] And given that Rubens was only disposed to paint those close to him, its existence argues for more than casual acquaintance.

Whereas imitating Rubens's style of living was a straightforward exercise for a man with a full purse, emulating and rivaling his towering achievement as a painter posed a far greater challenge to the youthful Van Dyck. Despite what eventually happened to him, there can be no doubt that the latter began his career with the intention of primarily becoming a history painter rather than a portraitist. In the works produced by Van Dyck in his early years, such as the *Saint Jerome* [FIGURE 26], probably the first surviving large-scale religious painting executed around 1615, there is a recognizable ambition to compete with the

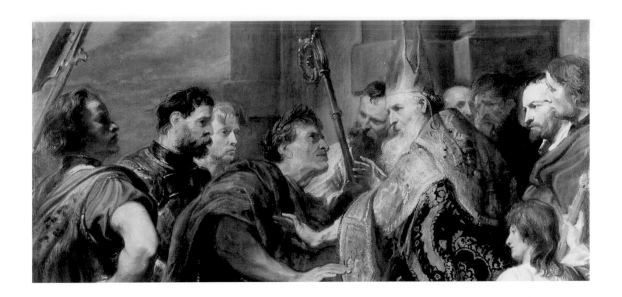

Above:

Figure 27
Anthony van Dyck.
*The Emperor Theodosius
Refused Entry into
Milan Cathedral* (detail),
circa 1619/20. Oil on
canvas, 149 × 113.2 cm
(58⅝ × 44⅝ in.).
London, National Gallery
(50).

Figure 28
Peter Paul Rubens.
*The Emperor Theodosius
Refused Entry into
Milan Cathedral* (detail),
circa 1618. Oil on
canvas, 362 × 246 cm
(142½ × 96⅞ in.).
Vienna, Kunsthis-
torisches Museum (524).

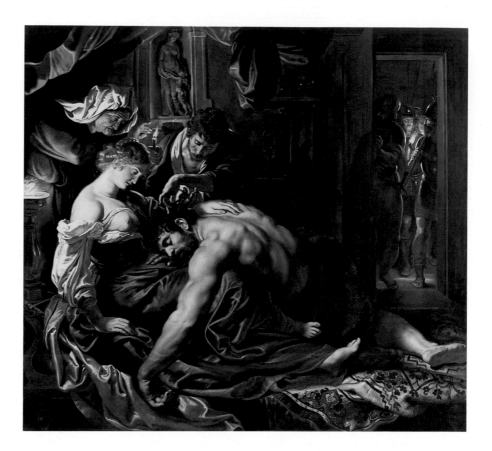

older master in his own subjects. Here he takes a contemporary painting of the subject (Gemäldegalerie, Dresden) as his starting point, which he then develops in a variety of styles, adopting a roughly painted naturalism. When he chose to, Van Dyck was a very skillful imitator of Rubens, as can be seen in his reduced version [FIGURE 27] of Rubens's painting *Emperor Theodosius Refused Entry into Milan Cathedral* [FIGURE 28], in which he significantly changes the appearance of two of the heads and introduces a clearly recognizable portrait of Rubens's patron Nicholas Rockox.[49]

In his treatment of heroic themes Rubens was superbly capable of producing the powerful solidity of form that gave the necessary monumentality to the realization of his subject. Because of his vivid imagination and clear definition of each participant in the fundamental stories of the Christian faith, Rubens was

the ideal Counter-Reformation artist, instructing and confirming the viewer in his faith. In contrast, Van Dyck's rendering of similar subjects, for all their brilliance of execution, tended for the most part to seek a different quality from the richly corporeal substance of Rubens's works. This difference is very apparent in the treatment by the two artists of the theme of Samson and Delilah, although separated from one another by about a decade. Rubens's version [FIGURE 29], painted just after his return from Italy, exudes immense strength and solidity, whereas Van Dyck's very personal reworking of the subject [FIGURE 30], possibly executed just before he went to England, shows much less sense of spatial depth and physical presence. It was only after he went to Italy in 1621 and came strongly under the influence of Titian, exchanging the heroic subjects treated by Rubens for more lyrical themes, that Van Dyck realized a new vein which obviated the contest of trying to compete with Rubens on his own terms.

Figure 30
Anthony van Dyck. *Samson Asleep in Delilah's Lap*, circa 1619/20. Oil on canvas, 149 × 229.5 cm (58⅛ × 89½ in.). London, Dulwich Picture Gallery (127).

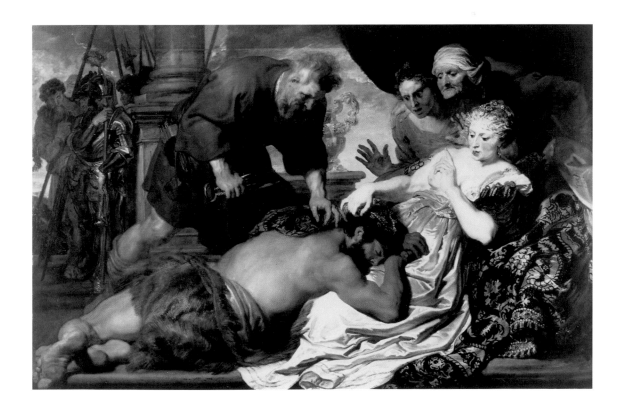

This fundamental divergence of character showed itself in the mind as well as in painting. Overall the younger man, even though capable of introducing erudite symbolism into his pictures when it seemed appropriate, did not have the wide intellectual interests of Rubens, who took pleasure in carrying on learned and lengthy disquisitions on archaeological matters with antiquarians and devoting his Sundays to designing title pages to books, replete with a wealth of learning and complex symbolism. As De Piles said of Van Dyck, "his Mind was not of so large an extent, as that of *Ruben's* [*sic*]" and of his paintings, "his *Invention* was not so learned, nor so Ingenious as his Master's."[50]

A different slant to their relationship is given by Bellori, who says that "it occurred to Rubens that his disciple was well on the way to usurping his fame as an artist, and that in a brief space of time his reputation would be placed in doubt. And so being very astute, he took his opportunity from the fact that Anthony had painted several portraits, and, praising them enthusiastically, proposed him in his place to anyone who came to ask for such pictures, in order to take him away from history painting." And taking up the topos of artists who "have in the end been unable to repress brilliant and highly motivated students," he compares the case of the two Flemish artists with that of Titian, who "dismissed Tintoretto from his house."[51] Whether Rubens was jealous or not, it can be said in his favor that since he himself was a reluctant portrait painter, largely limiting his sitters to very important patrons, friends, and family, he could feel some justification in handing on such commissions to someone who from the start of his career so clearly displayed a natural ability and taste for portraiture. Moreover, pushed by Rubens or not, there are no other records suggesting that the direction that Van Dyck's career was taking was seriously uncongenial to him. By the end of his visit to Italy, Van Dyck had become more prolific as a portraitist than a history painter.[52]

Already in his early subject pictures Van Dyck often introduces a portrait element, as was seen in the free copy after Rubens's *Emperor Theodosius* [FIGURE 27]. Taking this predilection a stage further, Van Dyck introduced the relatively small-scale devotional picture, which combined a religious subject with portraits of a donor and his family treated in a personal and domestic manner.

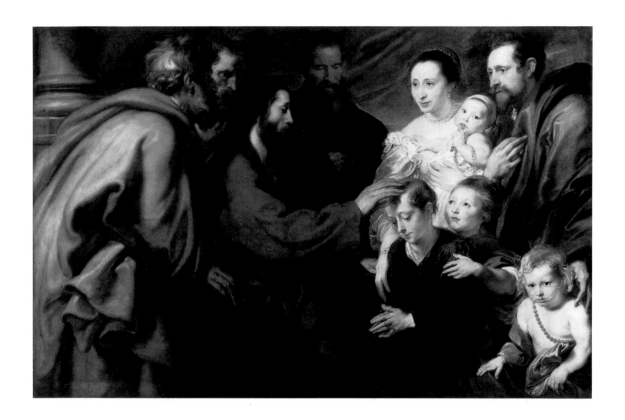

The painting *Suffer Little Children to Come unto Me* [FIGURE 31], probably exe-
cuted toward the end of the first Antwerp period, shows a religious subject with
the supplicants represented as real individuals, a family with four young children,
rather than with the conventional generalized features adopted by other artists.
The division between the spiritual scene on the left and the worldly one on the
right has been skillfully suggested by the use of a rich chiaroscuro for the former
while the family is revealed in strong natural light.[53] In a broader sense the picture
was an early example of the *portrait historié,* which was to become popular in

41

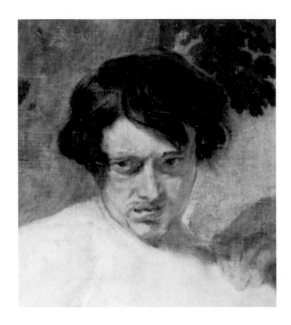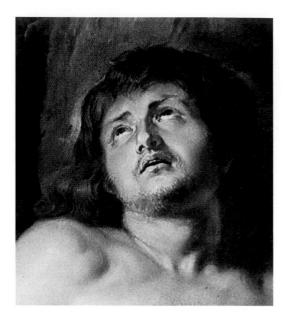

both the northern and southern Netherlands, and which Van Dyck himself returned to about the same time in the painting *Venus and Adonis* [FIGURE 47].

But even in his paintings of exclusively religious subjects, Van Dyck tends to give certain figures strikingly individual features which suggest to the viewer, whether intended by the artist or not, a recognizable model, as, for example, can be seen by comparing details of the head in the early painting of *Saint Sebastian* [FIGURE 32] with the idealized head in Rubens's version of the same subject [FIGURE 33], which was probably painted about the same time.[54]

The remarkably lifelike characterizations of some of the heads in his series of apostles, painted during the first Antwerp period, which clearly provided a starting point for Van Dyck,[55] stand out beside the set carried out by Rubens for the Duke of Lerma about 1610 (Museo del Prado, Madrid). Indeed, where Rubens often took a hint from the solution of an earlier artist, we have the sense that each of Van Dyck's apostles was studied directly from life, producing a representation of Christ accompanied by twelve highly distinctive individuals. They can be seen as the culmination of a group of individual studies of heads which Van Dyck must have painted shortly beforehand. By limiting the figures to

head and bust rather than half-length as in Rubens [FIGURE 34], Van Dyck realizes a greater intensity of expression. This concentration is perhaps nowhere more strongly felt than in the fervent, earnest image of Saint Peter [FIGURE 35], with his right hand holding the keys of the kingdom aloft, while his left is placed devoutly on his breast.

In view of the outcome of Van Dyck's career, it is pertinent that his first documented work is a portrait. The painting *An Elderly Man* [FIGURE 36], signed and dated 1613 and inscribed with the ages of the sitter (seventy) and, unusually, of the artist (fourteen), is a bust-length study in an oval format on canvas. Despite the young artist's natural pride, which led him to record his age, it is not a work of great distinction, but is a characteristic Antwerp product of the time, displaying a recognizable debt to sixteenth-century Venetian portraiture. The freshly painted head and millstone collar are brought to life with white highlights and contrast with the somber clothing and background.

Far more original is the *Self-Portrait* [FIGURE 37], which judging from the age of the sitter must have been painted about the same time. Such an early exercise in self-portraiture is revealing for an artist with a strong sense of narcissism, who was to paint himself more often than, for example, Rubens ever did. This first example must be nearly contemporaneous with the portrait of him painted by Rubens [FIGURE 25]. In both the sitter is seen looking over his shoulder, but both the glancing movement of the head and the expression on the face appear more spontaneous in Van Dyck's own image of himself. Moreover, the lack of a hat, revealing the golden curls falling over the face, increases the sense of informality. The large eyes with their quizzical but self-confident gaze and the full sensual lips give an extraordinary sense of vitality. It is a remarkably precocious performance for a boy of fourteen or fifteen. Whereas in the commissioned portrait of the old man he had to follow convention, in picturing himself he was free to demonstrate his search for originality. In Rubens's affectionate but more formal image, the sitter seems more withdrawn, deliberately hiding his feelings behind a cool searching stare, an effect enhanced by the hat covering the brow, which, although only added later, appears to replace some form of headgear.

The next documented stage in Van Dyck's development as a portraitist occurs only five years later, in 1618, the year in which he became a master

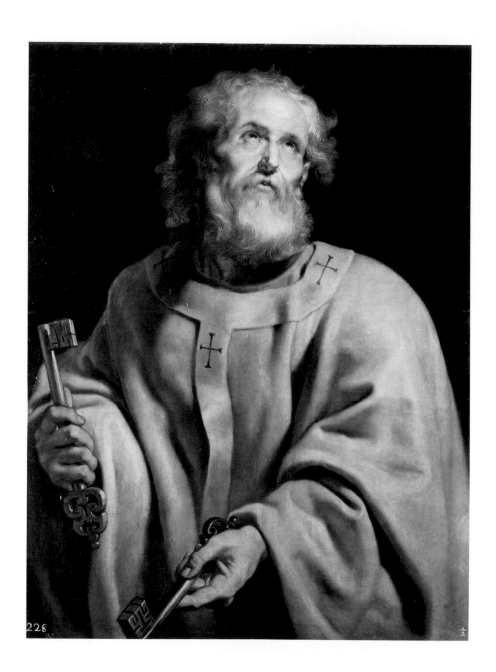

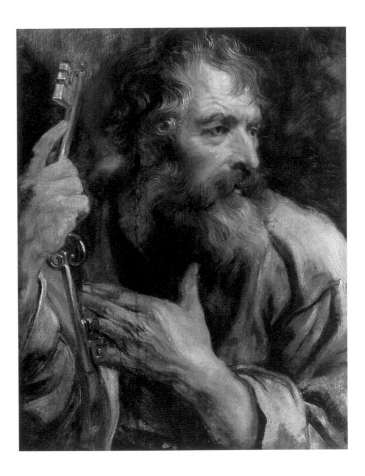

Figure 34
Peter Paul Rubens.
Saint Peter, circa 1610.
Oil on panel, 108 × 84
cm (42½ × 33⅛ in.).
Madrid, Museo del Prado
(1646).

Figure 35
Anthony van Dyck.
Saint Peter, circa
1620/1. Oil on panel,
62.5 × 49.5 cm
(24½ × 19½ in.).
New York, private
collection.

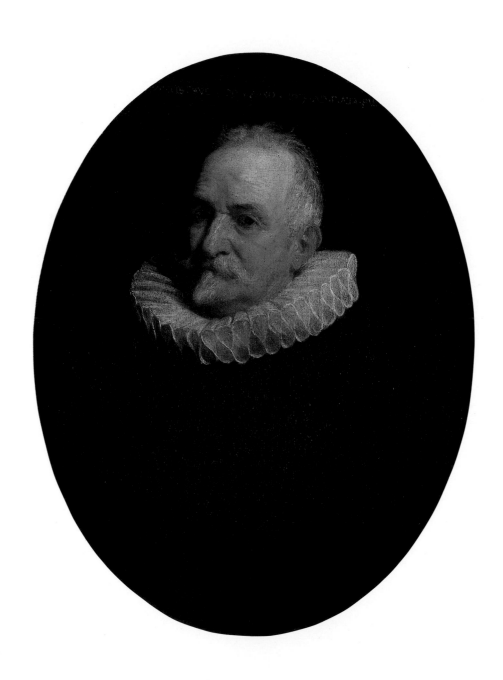

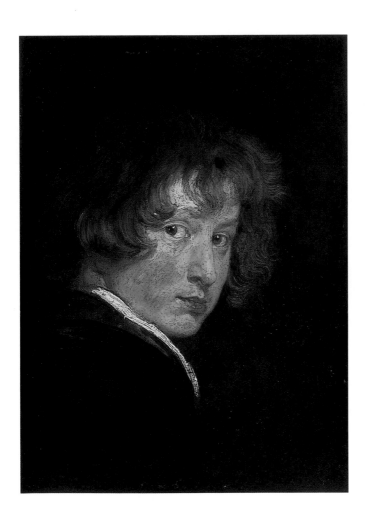

Figure 36
Anthony van Dyck.
An Elderly Man, 1613.
Oil on canvas, 63 ×
43.5 cm (23 × 17 ⅜ in.).
Brussels, Musées
Royaux des Beaux-Arts
de Belgique (6858).

Figure 37
Anthony van Dyck.
Self-Portrait, circa 1613.
Oil on canvas, 25.8 ×
19.5 cm (10 ⅛ × 7 ⅝
in.). Vienna, Gemälde-
galerie der Akademie der
bildenden Künste (686).

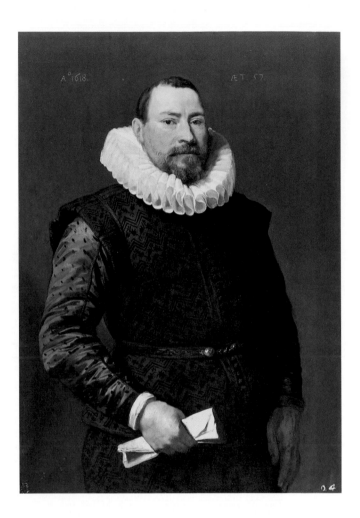

Figure 38
Anthony van Dyck.
*A Fifty-Seven-Year-Old
Man,* 1618. Oil on
panel, 105.8 × 73.5 cm
(41¼ × 28⅜ in.).
Vaduz, The Prince
of Liechtenstein (70).

of the Guild of Saint Luke and was allowed to practice independently. On two large panels prominently dated 1618, he imposingly portrayed a man and his wife, both aged fifty-seven, three-quarter-length [FIGURE 38].⁵⁶ Seen against a plain background, the static, soberly dressed figures follow a convention going back to the sixteenth century, introduced notably by Anthonis Mor both in the southern Netherlands and in Spain, which was continued contemporaneously by such artists as Frans Pourbus the younger. (Were more known about the early works of Frans Hals, who supposedly visited Antwerp in 1616, it might have been possible to attribute some of the directness of Van Dyck's treatment of his sitters to his

contact with the Haarlem artist.) Undoubtedly in the same year he painted, also on a large panel, a fifty-five-year-old man, who is seen three-quarter-length, resting his right arm on the back of a leather-upholstered chair embossed with gold [FIGURE 39]. These paintings must have alerted the citizens of Antwerp to the fact that a new and powerful portrait painter was available, one who, while following the accepted tradition, was gradually able to introduce his own individuality.

The painting of the fifty-five-year-old man is particularly revealing for its close relationship with Rubens who, although he painted relatively few portraits, established a general pattern for the decade. In 1616 the latter had painted a three-quarter-length portrait on panel, his favored support at this period, of the wealthy Antwerp burgher Jan Vermoelen [FIGURE 40]. The sitter, who looks calmly and seriously straight out at the spectator, is shown with his body turned half left, his left hand clasping his gloves and his right hanging by his side. He stands before a gold-embossed chair, which serves to project the powerfully conceived figure; apart from the coat of arms, the background is entirely plain. The beautifully assured brushwork, which skillfully builds up the flesh tones of the head and hands and suggests the material of the costume, has a very tactile presence in the finished work. With the largely vertical arrangement of the figure, varied only by the diagonal placing of the left arm across the body, it is a dynamic and very masculine presentation of the sitter, which emphasizes his physical presence.

Clearly Van Dyck must have been inspired by this work when two years later he came to portray an unidentified man [FIGURE 39], who was doubtless an eminent citizen of Antwerp, but with characteristic ambition he produced no slavish imitation.[57] Against a completely plain background, the sitter stands behind rather than in front of a leather-backed chair, which, grasped by the man's right hand, is treated as an active accessory rather than as a foil to the figure, as it had been in Rubens's picture. Compared with the overpowering physical presence of Jan Vermoelen, the sitter, more frontally placed behind the chair, is contained within the picture surface. But the young Van Dyck establishes contact with the spectator by his lively building-up of the flesh tones of the head with its intense outward gaze. Compared to Rubens, as Bellori, followed by other early critics, observed, "Van Dyck's flesh tones were more delicate and closer to the colours of Titian."[58] Although he emulates Rubens's fluid handling of the paint-

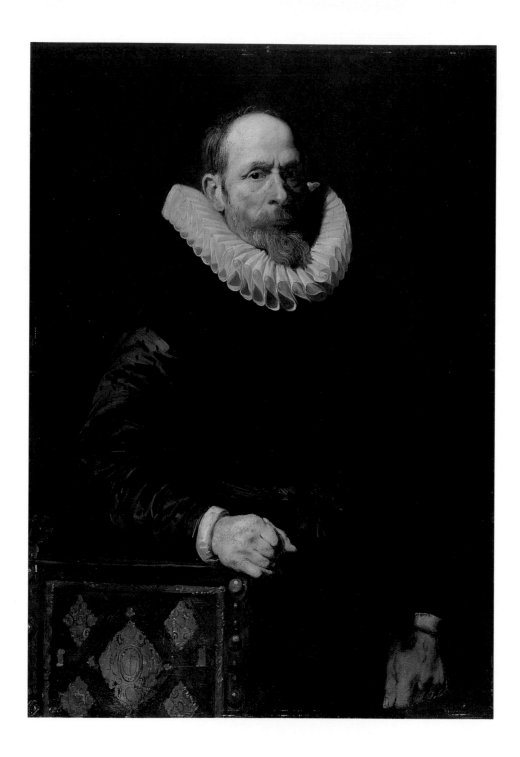

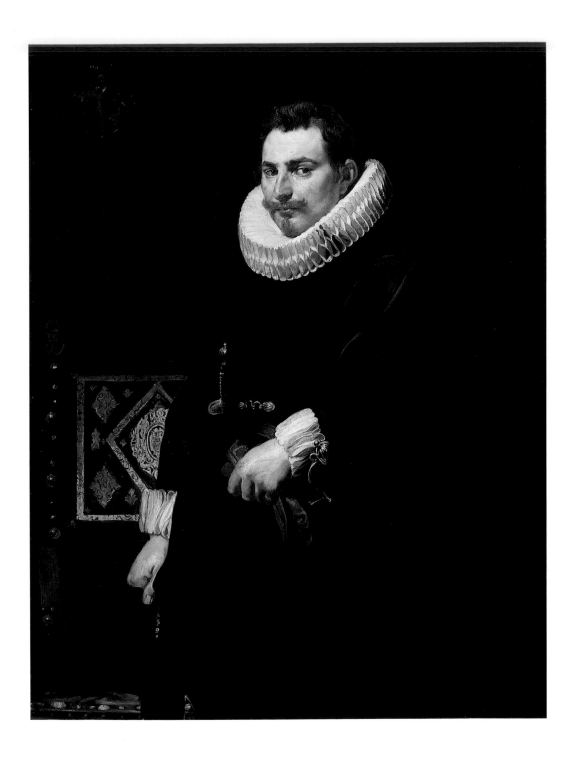

brush, he seeks a more varied surface pattern modified by the play of light rather than building up the form of the figure.

Where Van Dyck cannot match Rubens's experience is in the painting of the chair. By the simple expedient of leaving the ground uncovered, the latter is able to create the illusion of gold-embossed leather, an effect which Van Dyck is far less accomplished in suggesting. Moreover, in his modeling of the right hand, he lacks the older artist's mastery of touch, which eventually led him to develop his own manner of painting hands. (It is a curious fact that the right hand in both this portrait and that of the fifty-seven-year-old man of the same year are unfinished.) But one can observe the beginnings of the quintessential Van Dyck in the use of white paint to create a shimmering pattern of light playing over the right sleeve and belt tied in a bow of the black silk doublet, which glows in a range of tones against the neutral ground. Small, carefully placed touches enliven the expression of the face set off by the refulgent white ruff. The spontaneous and nervous execution creates more momentary image of the sitter, who, one senses, has been caught at a particular point in time in a mood more expressive of self-questioning than of the solid self-confidence which Rubens's sitter exudes.

Compared with his later portraits, these works are carefully worked and support what Roger de Piles was to record about Van Dyck's method. "The renowned Mr Jabach, well-known to all art lovers, who was a friend of Van Dyck, and who had him paint his portrait three times,[59] told me that one day when he spoke to the painter about the short time it took him to paint portraits, Van Dyck replied that at the beginning he worked long and hard on his paintings to gain his reputation and in order to learn how to paint them quickly during a period when he was working in order to have enough food to eat. This is, he told me, how Van Dyck usually worked."[60] Despite this account, it is notable that, although there are numerous working drawings for compositions during the first Antwerp period, there are none connected with portraits before the time he went to Italy. One is led to assume that the artist worked directly on the canvas without making any preparatory studies of heads or poses.[61]

When he came to paint the Earl of Arundel, Van Dyck had only just left the entourage of Rubens, and it is pertinent to observe how the latter prepared for portraits. The most circumstantial account of a portrait in the making is that

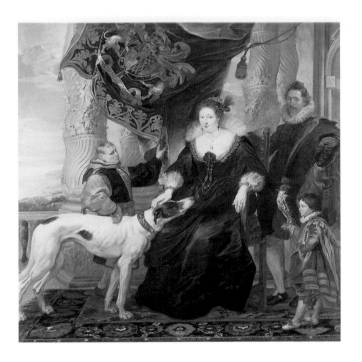

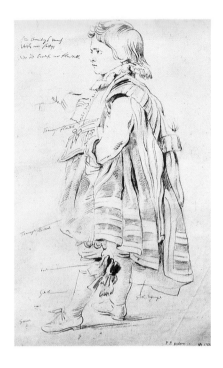

given to the Earl of Arundel in connection with the portrait *Aletheia Talbot, Countess of Arundel, and her Retinue* [FIGURE 41], painted in Antwerp in 1620, only a few months before Van Dyck portrayed Arundel. The letter from the earl's Italian secretary, Francesco Vercellini, already mentioned above, reported that since Rubens did not have a sufficiently large canvas to hand, he recorded the heads either in paint or drawing (it is not clear which) as they would appear in the final work, and then drew the poses and costumes on paper. (A study [FIGURE 42] for the figure of the dwarf, Robin, annotated with color notes, still exists.) But since Rubens was caught unawares by this unexpected commission, it is not certain that he was following his usual practice, although it is unlikely, in view of the way he worked, that he would have dispensed with drawing altogether.[62]

The tendency in Van Dyck's work toward introducing a more relaxed and lively presentation can be seen in another male portrait [FIGURE 43] on panel, also probably painted in 1618. The static effect of the head, with its intensely melancholic expression, encased in the millstone collar still in fashion, is con-

Figure 41
Peter Paul Rubens.
Aletheia Talbot, Countess of Arundel, and Her Retinue, 1620. Oil on canvas, 261 × 265 cm (102¾ × 104⅜ in.). Munich, Alte Pinakothek (352).

Figure 42
Peter Paul Rubens.
Robin the Dwarf, 1620. Pen and brown ink over black, red, and white chalk, 40.3 × 25.8 cm (15⅞ × 10⅛ in.). Stockholm, Nationalmuseum (1913/1863).

trasted with the lively motif of the left hand pulling on a glove on the other hand, while the left glove, unfinished, hangs from his fingers. In this shift toward a more *mouvementé* representation of the sitter, the motivating force unmistakably came from Venetian sixteenth-century painting, notably that of Titian and Tintoretto. Under this powerful influence, Van Dyck had developed by the end of the decade his own technique and personality in a number of quite varied portraits, both of single figures and of family groups, in which the backgrounds were opened up by the introduction of landscapes. Since almost without exception these more mature works are undated, it is impossible to establish whether they were painted before Van Dyck left Antwerp for England in 1620, or during the short period in England, or after his return to Antwerp before his departure for Italy in October 1621.

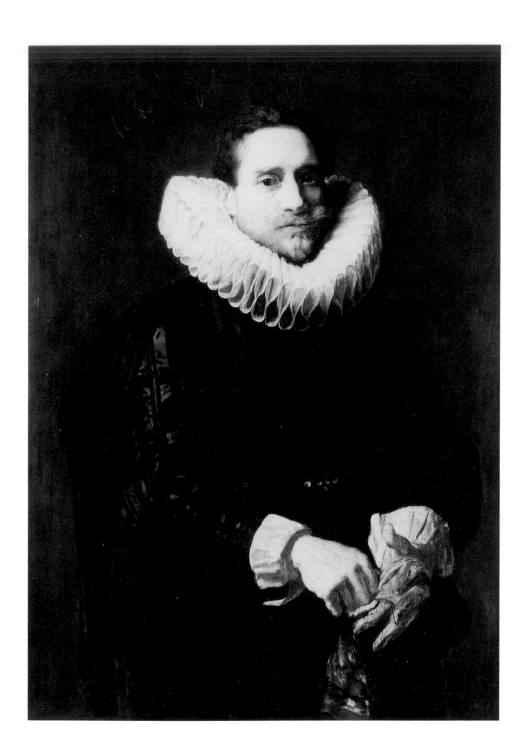

The Artist in London

Whether painted before or after these portraits, the *Earl of Arundel* has all the characteristics of the more mature Van Dyck. In the way that the head is turned and the hands are engaged holding either the badge or the folded paper, the portrait has a latent movement, which even if less overt than in such contemporary works as the *Self-Portrait* [FRONTISPIECE],[63] *George Gage with Two Attendants* [FIGURE 44],[64] or *Frans Snyders* (Frick Collection, New York), conveys a strong sense of lifelike vitality and relaxation. Instead of the plain backgrounds of his earlier portraits, the artist, now following the Venetian tradition of his more recent portraits, introduces a billowing curtain with its woven pattern and the vista of the sparkling landscape behind the sitter, which enhance this quality of movement.[65] The richer coloring now used by Van Dyck also reveals the effects of his growing passion for Titian. Largely abandoning panel for canvas, which now became the preferred support, the painter enlivens the surface with rough, dry brushstrokes heightened with numerous touches of white oil paint. Instead of previously trying, not entirely successfully, to emulate Rubens's strong, thickly impasted modeling, he now renders the hands with long tapering fingers of a kind which were to become a hallmark of his portraits; their elegance, at far remove from the thick working hands of Rubens, were entirely appropriate to the essentially aristocratic clientele he was to serve. The gentle, refined clasping of the Lesser George between the fingers conveys both the honor of the Order and the distinction of its recipient.

This change in Van Dyck's method of painting portraits served to reveal the character of the sitter in a more direct and natural manner, but at the same time establish his or her inherent grandeur. This quality was already recognized by Bellori, who wrote that "besides capturing a likeness, he gave the heads a certain nobility and conferred grace on their actions."[66] In such works Van Dyck created a new manner of portraiture which was to serve its purpose brilliantly, above all in Antwerp, Genoa, and London.

Figure 44
Anthony van Dyck. *George Gage (circa 1592–1638) with Two Attendants*, circa 1622/3. Oil on canvas, 115 × 113.5 cm (45 1/4 × 44 3/4 in.). London, National Gallery (49).

Some months before this portrait was executed, Arundel had, as already mentioned, commissioned Rubens to paint the countess and her entourage [FIGURE 41] on their visit to Antwerp. This encounter also served to introduce the name of the young Van Dyck to the English patron and provide the first intimation of the notion of attracting him to come and work in England. Reporting Van Dyck's continued presence in Rubens's studio, the letter from Vercellini to Arundel already cited, goes on to mention that "he is a young man of twenty-one years, his father and mother, very rich, living in this town; so that it will be difficult to get him to leave these parts; all the more, that he sees the good fortune that attends Rubens."[67] (It might be inferred from the way he is described that Van Dyck's was a new name to Arundel.)

But despite Van Dyck's apparent reluctance to leave Antwerp in July 1620, only three months later he was lured to London, where a recently discovered letter records him as living: "The young Painter Van Dyke is newly come to the town and brought me letters from Signor Rubens; I am told my Lord of Purbeck [the Duke of Buckingham's elder brother] sent for him hither."[68] A month later another correspondent writes to the English ambassador in The Hague, Sir Dudley Carleton, that Van Dyck, who was apparently living in London with George Geldorp (the painter from Cologne, whom Van Dyck would have known when he was a member of the Guild in Antwerp), had been given an annual pension of £100 by James I.[69] On February 16, 1621 the artist was paid £100 by the king for an unspecified "speciall service."[70] But two weeks later the Privy Council issued "A passe for Anthonie van Dyck gent his Ma^ties Servaunt to travaile for 8 months he havinge obtayned his Ma^ties leave in that behalf As was sygnified by the E of Arundell."[71] And four months after his arrival, the artist left London to return to Antwerp.

Today it is impossible to be certain whether Arundel or Buckingham was the prime mover in persuading Van Dyck to come to England, and the truth may be that as active patrons of the arts they both played a decisive role. In the letter mentioned above, which establishes the artist's arrival in England by October 1620, the writer reports that "I am tould" that Buckingham's brother "sent for him hither." But as we gathered from the earl's secretary, the thought was clearly in Arundel's mind at the time of the countess's visit to Antwerp, and when after

four months Van Dyck wished to leave England for a period of eight months, the king's permission for him to do so was "sygnified" by the earl.

These constitute the only known documents relating to Van Dyck's four months in England, and what he did remains tantalizingly unclear. He immediately found himself in the middle of a row about the painting *Tiger Hunt* by Rubens, which was being exchanged with a painting in poor condition by Bassano. Unfortunately no one in London believed that Rubens, as the latter claimed, had extensively retouched the picture produced by his studio, and Charles, then the Prince of Wales, for whom, unknown to Rubens, it was destined as a present from Lord Danvers, refused to hang it in his gallery. It was even suggested that, in the unlikely event that Van Dyck had brought over a record of the composition with him, Danvers would do better to get a copy of the subject made by Rubens's "famous Allievo" (i.e., Van Dyck) for half the price.[72] Whatever temporary harm the affair may have done to Rubens's reputation, it immediately gave Van Dyck the opportunity of meeting some of the major patrons at the English court. And at the same time he would have seen the recently completed Banqueting House, designed by Inigo Jones, with its ceiling awaiting decoration, a commission which was to be broached with Rubens in the following year.

The "speciall service" to the king remains unknown,[73] but Van Dyck did produce three existing pictures with clear English associations, which were presumably executed while he was in London. Apart from the Getty portrait of Arundel, these are two paintings of the *Continence of Scipio* [FIGURE 45] and the recently discovered *Venus and Adonis* [FIGURE 47]. The former illustrates the story of how the Roman ruler, after his conquest of New Carthage, restores, in an exemplum of generosity and continence, a beautiful female captive to her betrothed, Allucius, and gives her as a dowry the ransom gifts her parents had offered Scipio Africanus. In the other work, the more common subject of Venus and Adonis was treated as a *portrait historié*, a genre of painting new to the English court, which was becoming popular on the Continent, and represents the couple standing seminaked in a landscape; Adonis, with a hound jumping up beside him, has his arm around Venus's shoulder and looks tenderly at her.

The Continence of Scipio almost certainly belonged to the Duke of Buckingham, whose paintings by Veronese may well have influenced its design

Figure 45
Anthony van Dyck.
The Continence of Scipio,
1620 or 1621. Oil on
canvas, 183 × 232.5 cm
(72 × 91½ in.).
Oxford, Christ Church.

Figure 46
Unknown (Smyrna,
second century A.D.).
*Fragment of a
Frieze with Two Medusa
Heads.* Marble,
146 × 65 cm (57 ½ ×
25 ⅜ in.). London,
Museum of London,
on long-term loan from
a private collection.

and execution. It is unlikely, however, as has been suggested, that it portrays Buckingham and his wife in the roles of the reunited lovers, Allucius and the beautiful unnamed captive. In fact Scipio, among the dramatis personae, has more the appearance of an identifiable individual, although his features do not, as has been proposed, closely resemble those of James I.[74] The apparent portrait element may be due once again to the artist's penchant for apparently depicting his historical figures in the likeness of real models. The Buckinghams were, it has been argued, daringly used as personifications in the painting of *Venus and Adonis* [FIGURE 47].[75] In May 1620, several months before Van Dyck's arrival, Buckingham, at that time a marquis, had married Lady Katharine Manners, daughter of the Earl of Rutland, so that two such personal works would have been entirely appropriate, all the more so since the marriage had, with the opposition of the bride's father, proved difficult to arrange. In the *Venus and Adonis* the twisted tree trunks may, following the emblem given by Alciati, be interpreted as a symbol of their union.

But in the case of *The Continence of Scipio,* painted in the fluid linear style of the period, the association with Buckingham is complicated by the recent discovery on the site of Arundel House of the fragment of a classical frieze with two Medusa heads [FIGURE 46], recorded as belonging to the Earl of Arundel in 1639, and clearly identical to that which appears in the lower left of the picture.[76] It has been said that the presence of this substantial piece of Arundel property

indicates that Arundel was responsible for commissioning the canvas from Van Dyck as a wedding present for Buckingham.[77] But the prominence in the picture of Arundel's sculpture, clearly regarded as a prize possession, would make it a tactlessly pointed gift to a rival collector with whom relations were distinctly uneasy. The truth may rather be that the picture was in fact commissioned by Buckingham, as had previously been thought, and that the relief, which is sufficiently complete and well preserved to appeal to his taste, originally formed part of his collection of sculpture at York House and was only later acquired by Arundel, probably after the duke's death in 1628.[78]

Both the straightforward portrait of Arundel and the *portrait historié* of Buckingham and his wife as Venus and Adonis would have struck the English court as new in concept and marvelously free in execution when they were compared with contemporary examples of portraits produced in England. Patrons may well have felt that at last a truly outstanding artist was to hand; James I, like other European rulers of the period, was anxious to attract major painters to come and work for his court, even if in England the prime business was the execution of portraits. Under the reign of Elizabeth, when for political reasons contact with the Continent was forbidden, the most distinguished portraits were executed in miniature by such artists as Nicholas Hilliard (1547–1619) and Isaac Oliver (c. 1565–1617). Although full-length portraits were painted, the growing desire for a more up-to-date and naturalistic style of portraiture, matching what was being produced at other European courts, made it necessary to look abroad. As both the English portraits of Charles I as Prince of Wales [FIGURE 7] by Robert Peake, and Buckingham [FIGURE 8], possibly by William Larkin show, sitters were depicted richly and elaborately dressed, placed against colorfully patterned backgrounds, in a style which revealed more of their social and financial status than of their individual character.

In 1611 there had been a serious attempt to persuade Michiel van Miereveld, the leading portrait painter at The Hague, to come and work for Henry, Prince of Wales. The English court had greater success with Paul van Somer (c. 1576–c. 1622), born in Antwerp but active in various cities in the northern Netherlands, who came to England in 1616. He was soon working for the Crown, and became Queen Anne's favorite painter. His very large portrait of

Figure 47
Anthony van Dyck.
Sir George Villiers (later Duke of Buckingham) and Lady Katherine Manners (died 1649) as Adonis and Venus, 1620 or 1621. Oil on canvas, 233.5 × 160 cm (88 × 63 in.). London, Messrs. Harari & Johns Ltd.

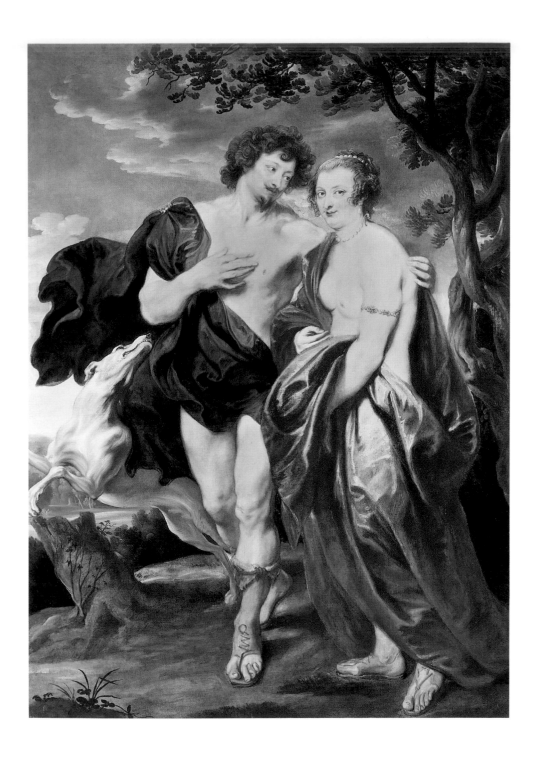

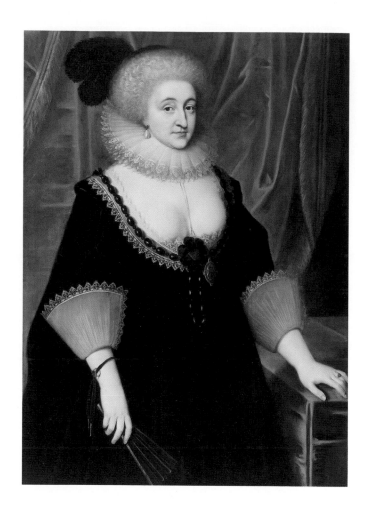

Figure 48
Paul van Somer.
*Elizabeth Talbot, Count-
ess of Kent (1581–
1651)*, circa 1618/20.
Oil on panel, 114.3 ×
82.6 cm (45 × 32½ in.).
London, Tate Gallery
(T.G.T. 00398).

the queen [FIGURE 9], dated 1617, represents her in a landscape rather than in
the usual plain interior, dressed for the chase, accompanied by a black groom,
horse and Italian greyhounds with a ribbon bearing the Italian legend, *La mia
grandezza dal eccelso;* the distance contains a view of the royal palace of Oatlands
in Surrey, for which Inigo Jones had just completed a classical gateway. By allud-
ing to Anne's taste for hunting and patronage of architecture as well as asserting
the divine guidance with which she felt herself inspired, the portrait, which was
more vigorously and assuredly painted than any previous work executed in
England, gives a much more rounded image of the sitter. Less ambitious is the

portrait of Elizabeth Talbot, Countess of Kent [FIGURE 48], elder sister of the Countess of Arundel, which was probably painted a year or two later. Although the firm modeling of the sitter gives her a naturalistic appearance, the pose is stiff and the curtained interior conventional, so that the picture must have appeared old-fashioned when compared with what Van Dyck was about to produce for her brother-in-law.

Van Somer was followed to England two years later in 1618 by Daniel Mytens (c. 1590–1647), from The Hague, who became by far the most distinguished foreign artist to work at the English court on a long-term basis before Van Dyck finally settled in England in 1632. Looking out for new talent had become the preoccupation of a number of English courtiers, above all Arundel, the undoubted *arbiter artium* at this period. Since Mytens is referred to by Sir Dudley Carleton, the English ambassador in The Hague, in 1618 as "your lordship's painter,"[79] he presumably came to England at Arundel's invitation, but by 1620 he was carrying out work for the Crown. (On Charles I's accession in 1625, he was appointed one of the king's "picture drawers in ordinaire.") Arundel, attired for the barriers, had already been portrayed in a characteristically stiff pose [FIGURE 12] by an anonymous artist about 1610, but Mytens's large and impressive portrait of the earl seated in a sculpture gallery [FIGURE 16], with its pendant of the countess seated in a picture gallery [FIGURE 18], the first documented full-lengths carried out by Mytens, offered something new, both in the earl's iconography and in English portraiture. More fully modeled, they provide much more naturalistic images than anything produced in England before, even if at this stage of the artist's career the figures are not as convincingly absorbed into their setting as they were to be in later portraits. [80]

The grandest and most outstanding portrait of the Arundel family is unquestionably the large painting *Countess of Arundel and Her Retinue* [FIGURE 41], painted by Rubens in the summer of 1620, which has already been mentioned. This exceptional work, unmistakably Venetian in coloring, must have opened English eyes to the full possibilities of Baroque portraiture. The Countess of Arundel, on her way to Italy, had stopped in Antwerp, where Rubens was without warning requested by the earl to paint her portrait. Seated on a terrace covered with an oriental carpet before four massive twisted salomonic columns,

Lady Arundel is attended by a standing male figure, now usually identified as Sir Dudley Carleton, English ambassador at The Hague; Robin, her dwarf; and her jester with his dog. In scale and magnificence the picture is a development of the style of portraiture which he had created so memorably in Genoa over a decade earlier.[81]

It was a tribute to Arundel's position and reputation that Rubens, having read the earl's letter requesting this unexpected commission, said: "Although I have refused to paint the portraits of many princes and gentlemen (particularly here, in the State of her Highness [Archduchess Isabella, Infanta of Spain]), yet I cannot refuse the Earl the honour he does me in commanding me, holding him for one of the four evangelists, and a supporter of our art."[82] Despite his known reluctance to undertake portraits, the artist may well have thought that it would do his reputation no harm to have a major example of his work hanging in the house of a member of a court he had yet to conquer.

If Van Dyck's portrait of Arundel was never intended to match the scale and grandeur of the group portrait by Rubens, it must, when compared to the work of other portrait painters active at the English court, have stood out for its relaxed and sophisticated manner of presenting the sitter. The ease with which he holds himself must have contrasted favorably with the unbending image of the earl in his sculpture gallery [FIGURE 16] or the frozen starchiness of his sister-in-law [FIGURE 48], painted by Van Dyck's two leading predecessors. Van Dyck's few months in England gave a brilliant intimation of his great potential as an artist, which must have made his sudden departure all the more keenly disappointing for his new and admiring patrons.

Epilogue

On or shortly after February 28, 1621, Van Dyck left England ostensibly for eight months, but in fact he was not to return until 1632, well into the reign of Charles I. Although Van Dyck and the Countess of Arundel may have come together in northern Italy in 1622 or 1623, the artist and the earl were not to meet for a period of eleven years. And even when Van Dyck did return to England in 1632, he was so absorbed in working for the new king that four years elapsed before any commissions from Arundel materialized and, one may speculate, before there was any renewal of their close relationship.

With the death of James I in 1625, life at the English court did not become any easier for Arundel. The new king found the company of Buckingham far more congenial and, despite Charles's and Arundel's common interest in the arts, there was undoubtedly an awkwardness in their relationship. Apart from difficult external events, this may well have been partly due to the earl's aloofness and inability to create a sense of ease and intimacy in his relations with others. As his secretary said, Arundel "was a great Master of Order and Ceremony, and knew and kept greater Distance towards his Sovereign than any Person I ever observed, and expected no less from his inferiors." And describing his master's different relations with James and Charles, Walker claimed that "the first . . . I believe loved him more, and the last had him in greater Veneration and Regard (though not in intimacy of Favour) he being a Person by Years, Quality and Parts, of an austere Disposition, and not so complacent as other Persons that had more of Ends."[83] Buckingham was clearly much more relaxed and entertaining and showed himself no less adept at winning the new king's favor than he had done with the latter's father.

Only a year into the new reign an uneasy relationship was brought to crisis point by the secret marriage between Lord Maltravers, Arundel's eldest son, and Lady Elizabeth Stuart, daughter of the Duke of Lennox, for whom, because of political advantages, the king had favored another husband. Arundel was

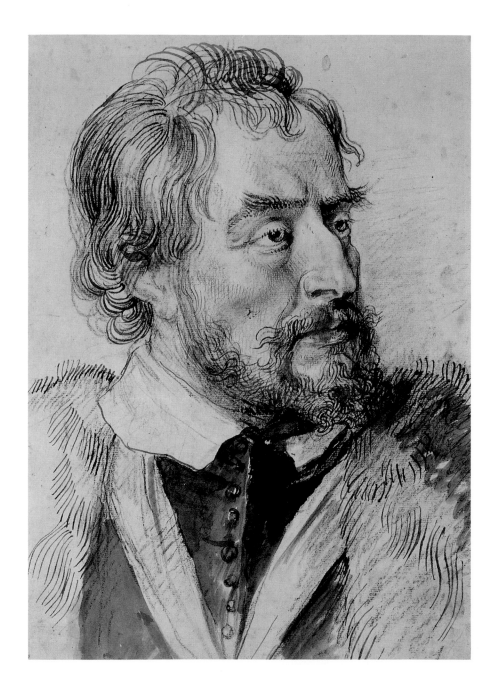

Figure 49
Peter Paul Rubens.
Thomas Howard,
2nd Earl of Arundel,
1629/30. Pen and
brush in brown ink over
black and red chalk,
washed with white body-
color, 28 × 19 cm
(11 × 7 ½ in.). Oxford,
Ashmolean Museum.

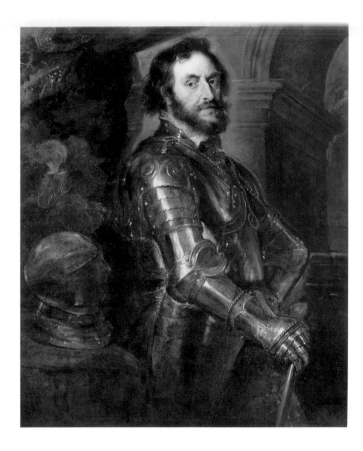

Figure 50
Peter Paul Rubens.
Thomas Howard,
2nd Earl of Arundel,
1629/30. Oil on canvas,
127 × 101.6 cm
(50 × 40 in.).
Boston, Isabella
Stewart Gardner
Museum.

unjustly held responsible for the marriage and was sent to the Tower, from where he was only released under pressure from the House of Lords. But even then he remained out of favor with the king until a reconciliation was brought about in July 1628. Only a month later Buckingham was assassinated, and shortly afterward Arundel was said to have "grown into great grace with the King."[84] He once again occupied his apartments at the royal palace at Whitehall, and as a mark of the new relationship, Charles, with the queen, paid a visit to Arundel House to inspect Arundel's collection.

Undoubtedly the most exciting contemporary artistic event, of which Arundel took full advantage, was the visit of Rubens to England on a diplomatic mission between June 30, 1629 and March 23, 1630. It gave the Flemish artist an opportunity to revise his previously unfavorable opinion of the country and its

inhabitants, so that he now felt moved to say that "This island . . . seems to me to be a spectacle worthy of the interest of every gentleman, not only for the beauty of the countryside and the charm of the nation; not only for the splendor of the outward culture, which seems to be extreme . . . but also for the incredible quantity of excellent pictures, statues, and ancient inscriptions which are to be found in this court." Rubens, who already, as we know, held the earl in high esteem, took the opportunity to visit the collection of ancient marbles at Arundel House, which he had already studied in Selden's *Marmora Arundelliana*, published the previous year. Having seen them he wrote, "I confess that I have never seen anything in the world more rare, from the point of view of antiquity." [85] And during his stay in London he drew *ad vivum* the beautiful portrait study of the earl, executed in red and black chalk and then, unusually, worked over extensively with pen and brush in brown ink and white body-color [FIGURE 49]. Although not corresponding exactly with any of the three painted portraits Rubens subsequently made either in London or on his return to Antwerp, this study surely served as a record of the sitter's likeness. Two of the paintings are bust-length, [86] while the third, the most spectacular, represents the sitter three-quarter-length, dressed in glowing armor and standing before a wine-red curtain [FIGURE 50], providing an image of a great noble as romantic as any painted in the seventeenth century.

For Van Dyck the intervening years between his visits to England witnessed a steady increase in his reputation as a painter. After a few months following his return from London to Antwerp, he set off in October 1621 for what was to be a six-year visit to Italy. During this time he was able to immerse himself in Italian art, above all in the work of Titian, which was to have such a profound and beneficial effect on his future work. (What he admired can be gauged from the copies he made in the sketchbook which he took with him. [87]) And from the commissions from Genoese patrons and princes of the Roman church, he created an international style of aristocratic portraiture, which was to serve him so well in his later years in England.

Back in Antwerp, probably in the autumn of 1627, Van Dyck showed no sign of fulfilling his much overdue obligations of returning to the English court, although he would have been aware that the death of James I and the accession of his son presented a different situation. He settled in Flanders and became

one of the Infanta Isabella's court painters, but during this time he was not entirely forgotten in England and he received a major commission from Charles I for a mythology. This is always assumed to be the *Rinaldo and Armida* (Baltimore Museum of Art), which with its explicit Venetian richness and sensuousness would have amply demonstrated to the aristocratic connoisseurs at the English court the transformation in his work. According to tradition this work played an important part in persuading Charles I to invite Van Dyck to return to England.[88] Whatever role the picture played, the artist was successfully lured back three years later, in 1632. Bellori unequivocally gives the credit to Arundel, who, he says, "had introduced Van Dyck into the king's favour and had been instrumental in bringing him to England."[89] To make Van Dyck feel welcome he was promptly knighted and, no doubt to the chagrin of Daniel Mytens, court painter since 1622, made "principalle Paynter in ordinary to their Majesties," an honor which Van Dyck repaid by effecting a remarkable transformation of the English court portrait. (At the same time it appears that Jan Lievens was in England and was engaged in painting portraits of the royal family, although none have survived.) Van Dyck was made much of by the king, who demonstrated his delight with his new painter with gifts and numerous commissions. At first Charles I clearly monopolized Van Dyck's services, and there is no record of any contact between the artist and Arundel.

Only after Van Dyck's return from a yearlong visit to Antwerp in the spring of 1635 was Arundel's patronage renewed, and during the next four or five years the artist executed a series of what can be called dynastic portraits for the earl and his family. Three commissions in or around 1635 led to the movingly affectionate three-quarter-length portrait of the earl dressed in armor, with his arm around his grandson, Thomas, then aged about eight or nine [FIGURE 51], as well as portraits of Arundel's son Lord Maltravers, and his wife, Elizabeth Stuart, the parents of Thomas.[90] And in 1639 Van Dyck painted that curious historical piece, the double portrait of the earl and countess, seated before a globe [FIGURE 52], to which both are pointing, he with his finger and she with a pair of dividers, at the island of Madagascar.[91] It was commissioned to commemorate the proposed British colonization of the island by a force to be led by Arundel. The project was abandoned, possibly owing to the illness of Arundel, who in any case,

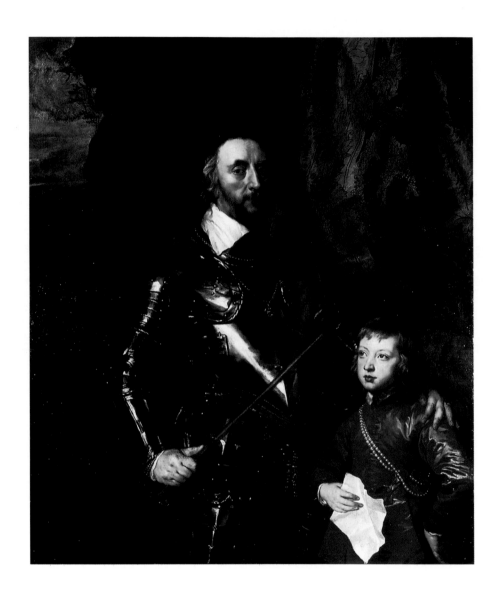

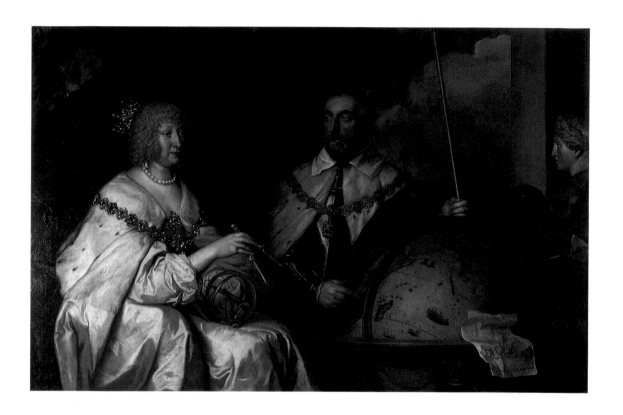

Figure 51
Anthony van Dyck.
Thomas Howard,
2nd Earl of Arundel with
His Grandson, Later
5th Duke of Norfolk
(1627–1677), circa
1635/6. Oil on canvas,
145.4 × 121.9 cm
(57½ × 48 in.). Arundel
Castle, The Duke of
Norfolk.

Figure 52
Anthony van Dyck.
"The Madagascar
Portrait": *Thomas*
Howard, 2nd Earl of
Arundel, with Aletheia,
Countess of Arundel,
1639. Oil on canvas,
135.3 × 210.8 cm
(55 × 83¾ in.). Arundel
Castle, The Duke of
Norfolk.

at the age of fifty-four and without appropriate experience, was unfit to carry out such a hazardous exercise.

In addition to the existing portraits, there is some inconclusive evidence that Van Dyck was planning a large family portrait on the same magnificent scale as that carried out for the fourth Earl of Pembroke (Wilton House) in about 1634 or 1635 and before that, in 1632, for Charles I and his family (Royal Collection). A drawing by Van Dyck of the full-length seated figure of Arundel [FIGURE 53] has, with its reminiscences of the figures of Charles I and the Earl of Pembroke seated in their great family portraits, the appearance of a study connected with a larger composition. In addition there is an elaborate group of the earl and his family by the Flemish artist Philip Fruytiers, known in a painting [FIGURE 4] copying a watercolor that is inscribed "An. VANDYKE Inv." and signed and dated 1643, two years after Van Dyck's death, when both Arundel and the countess were living in Antwerp.[92] With its portrayal of the earl and countess with their grandchildren, who present Arundel with the traditional family heirlooms—the sword, helm, and gauntlet worn by the second Duke of Norfolk at Flodden, and the Italian sixteenth-century pageant shield—and with the display of the Holbein portraits of his forbears, the third Duke of Norfolk [FIGURE 5], and his son, the "poet" Earl of Surrey [FIGURE 6], on the background wall, it has all the elements that would have fulfilled the earl's wishes for a monumental dynastic portrait. But the composition as represented by Fruytiers shows weaknesses that can hardly be directly attributable to an artist of the stature of Van Dyck, and it is unlikely that it represents an accurate record of what Van Dyck may have intended.[93] Nevertheless, it is easy to imagine that a more sophisticated version of such an ambitious assembly of past and present, echoing Holbein's great portrait of Thomas More and his family in Arundel's collection [see FIGURE 20], would have greatly appealed to the earl's family pride. Such a major picture would also have provided a fitting climax to his relationship with Van Dyck, which started so auspiciously nearly twenty years earlier with the eloquent portrait of the man [see FIGURE 1, FOLDOUT], held up in his time as "the Image and Representative of the Primitive Nobility" who exhaled the "Native Gravity of the Nobles when they had been most Venerable."[94]

NOTES

1. The painting is first recorded in 1727 in the collection of Philippe, Duc d'Orléans (the regent) and passed by descent to Philippe, Duc d'Orléans (Philippe Egalité), 1792; Citoyen Robit, sale Paris, 11 May 1801, lot 36; Michael Bryan, sale Bryan's, London, November 6, 1801–May 31, 1802, no. 92, bought by 3rd Duke of Bridgwater; by descent to 1st Duke of Sutherland, before 1913; Daniel Guggenheim, New York, 1929; Robert Guggenheim, Washington, D.C., 1950; Mr. and Mrs. Francis Lenyon, Washington, 1980; John A. Logan, Washington, D.C., 1980; Mrs. Rebecca Pollard Logan, sale Christie's, July 8, 1983, lot 92, bought by Messrs. Agnew for Jamie Ortiz Patino, Switzerland, in whose collection it remained until bought by the Getty Museum through Messrs. Agnew, London.

 Selected bibliography: (see Bibliography) Hervey, pp. 187–88; Glück, pp. 125, 533; Huemer, p. 90; McNairn, no. 65; Millar (1982), no. 2; Brown (1982), pp. 55–56; Larsen, no. 38.

 What undoubtedly is only an inferior copy by another hand is in a Swiss private collection (Larsen, no. 39, repr., as by Van Dyck). An early copy of the head and hands only is in a private collection in Stockholm.

2. E. Walker in D. Howarth, *Lord Arundel and His Circle* (New Haven and London, 1985), p. 221. Sir Edward Walker served as Arundel's secretary on his embassy to Germany in 1636.

3. Clarendon; Howarth (note 2), p. 221. It should be noted that Clarendon was ill-disposed towards Arundel.

4. Clarendon; Howarth (note 2), p. 219.

5. Walker in Howarth (note 2), p. 222.

6. *Marescalia or a catalogue of the Marshalls of England With their succession in order from the type of King Henry the First untill this present yeare. . . .* (1638). The book, which remains in family possession, is attributed to the painter and "limner" Henry Lilly, who executed the book containing the family history referred to on p. 4, also now at Arundel Castle. (For a more detailed description, see D. Howarth, N. Penny, *et al.* (see Bibliography), no. 19).

7. L. Hutchinson, *Memoirs of the Life of Colonel Hutchinson*, ed. J. Sutherland (Oxford, 1973), p. 46.

8. This gesture caused Arundel and his wife considerable embarrassment since they had already approached the latter's grandmother, the redoubtable Bess of Hardwick, who had to be tactfully alerted to the royal offer, which never materialized.

9. "Historical Account of Thomas Howard, Earl of Arundel, by His Son, William Howard, Lord Stafford," in M. Hervey, *The Life, Correspondence and Collections of Thomas Howard, Earl of Arundel* (Cambridge, 1921) p. 465.

10. Historical Manuscripts Commission: Hatfield, vol. 21, p. 39, quoted in R. Strong, *Henry Prince of Wales* (London, 1986), p. 188.

11. Hervey (note 9), p. 465.

12. *State Papers, Venice,* 12, 1613 (49); p. 67.

13. Letter, dated March 12, 1616, from Arundel's *cicerone,* the painter William Smith, who was seeking the former's patronage, in Hervey (note 9), p. 65.

14 Letter to William Trumbull in Brussels, August 7, 1612, in Howarth (note 2), p. 228, n. 6.

15 There is no evidence (*pace* Howarth (note 2), p. 33, following J. Rowlands, *Rubens Drawings and Sketches,* exh. cat. (The British Museum, 1977), p. 16), that Rubens went to Spa and painted a portrait of Arundel, now lost.

16 Arundel to Countess, March 14, 1614, in Howarth (note 2), p. 44.

17 E. Walker, *Historical Discourses upon Several Occasions,* ed. H. Clopton, (London, 1705), pp. 209–33; Howarth (note 2), p. 33.

18 Both Henry Peacham, who may have been a member of Arundel's party, in the revised edition of *The Compleat Gentleman* (1634), p. 107 (Hervey [note 9], p. 84, n. 3) and Edward Alleyn, the King's Player, in his diary for April 17, 1618 (Howarth (note 2), p. 236, n. 16), speak of Arundel bringing statues back from Italy.

19 P. de Chennevieres and A. de Montaiglon, eds., "Abecedario de P. J. Mariette et autres notes inedites de cet amateur sur les arts et les artistes," in *Archives de l'art français, 3* (1854–56), pp. 142–3, 297, 314–16; see J. Sumner Smith, "The Italian Sources of Inigo Jones's Style," *Burlington Magazine,* (1952), p. 204, and J. Wood, "Inigo Jones, Italian Art, and the Practice of Drawing," *Art Bulletin* 74 (1992), p. 253.

20 Hervey (note 9), p. 487; Inventory of 1655, no. 320, now in the P.R.O., London.

21 Rubens to Peiresc, London, August 9, 1629, in R. S. Magurn, *Letters of Peter Paul Rubens* (Cambridge, Mass., 1955), p. 322.

22 The backgrounds of the two portraits show an archway with a view of the Thames on the first floor and a doorway revealing a formal garden closed by a gateway on the ground floor. But according to views of the exterior, such as Hollar's drawing (fig. 17), the end wall of the gallery wing contained only two mullion and transom windows on each floor (see also Howarth (note 2), pls. 63, 65–66). Through a misreading of a letter written by Edward Sherburn (see notes 9 and 27; Hervey, p. 101), Howarth (note 2), p. 58, argues that the sculpture gallery was on the ground floor and the picture gallery above. Howarth's supposition is also contradicted by Sandrart's account (see below).

A more extensive and possibly more accurate view of the garden decorated with statuary appears in the background of an anonymous portrait of the earl in the collection of Lady Anne Cavendish-Bentinck at Welbeck Abbey (Howarth (note 2), pl. 67).

23 J. von Sandrart, *Teutsche Academie,* vol. 2, (1675), trans. M. Hervey (note 9), pp. 255–56.

24 Henry Peacham, *The Compleat Gentleman,* 2nd ed. (London, 1634) pp. 124–25.

25 T. Tenison, *Baconiana* (London, 1679), p. 57; D. Haynes, *The Arundel Marbles* (Oxford, 1975), p. 7.

26 T. Birch, *Court and Times of James I,* vol. 1 (1848), p. 428; Haynes (note 25), p. 4.

27 Edward Sherburn to Sir Dudley Carleton, 9 April 1616, in Hervey (note 9), p. 101.

28 O. Millar, *The Age of Charles I: Painting in England 1620–1649,* exh. cat. (London: Tate Gallery, 1972), p. 11, without source.

29 It is a nice irony that today some of Peiresc's lost antiquities, including the *Parian Marble,* are housed in the same collection as Rubens's painted copy of the *Cameo of Germanicus,* made as a special present for the Frenchman.

30 Arundel to Carleton, September 17, 1619, in Hervey (note 9), p. 162.

31 The Duke of Buckingham to Sir Thomas Roe, 19 July 1626, in Sir Thomas Roe, *Negotiations in the Levant,* ed. S. Richardson, (1740), p. 354.

32 G. Goodman, *The Court of King James the First*, vol. 2, (1839), p. 370.

33 Francesco Vercellini (?) to Arundel, Antwerp, July 17, 1620, in Hervey (note 9), p. 175.

34 Hervey (note 9), p. 469.

35 Arundel to Carleton, July 20, 1621, in W. Sainsbury, ed., *Original Unpublished Papers Illustrative of the Life of Peter Paul Rubens* (London, 1859) pp. 291–2. This picture, which is not mentioned in the 1655 inventory, can be seen as a prelude to Honthorst's visit to England in 1628, when, however, his patrons were the king and the Duke of Buckingham and not Arundel.

36 Walker (note 17); Howarth (note 2), p. 222.

37 For important revisions about Van Dyck's early life, see K. van der Stighelen, "Young Anthony: Archival Discoveries Relating to Van Dyck's Early Career," in S. Barnes and A. Wheelock, eds., *Van Dyck 350*, (Washington, D.C., 1994), pp. 17–46.

38 Letter from Venetian ambassador to the Netherlands, dated July 14, 1629 in *Calendar of State Papers, Venetian*, ed. A. B. Hinds, vol. 22, p. 130 (G. Martin, *National Gallery: The Flemish School* (1970), p. 122). This description tallies with that given by Bellori, who speaks of Rubens's penchant for "riding through the city, like other *cavalieri* and persons of title," in G. P. Bellori, *Le Vite de pittori, scultori ed architetti*, (Rome, 1672) trans. C. Brown (1991) (note 43), 17–46.

39 Bellori, Brown (note 38), (1991), p. 18.

40 For the most recent discussion of this subject, see S. Barnes, "The Young Van Dyck and Rubens," in A. Wheelock et al., *Anthony Van Dyck*, exh.cat. (Washington, 1990), pp. 17–25, and J. S. Held, "Van Dyck's Relationship to Rubens," in Barnes, Wheelock (note 37), pp. 63–76.

41 A. Felibien, *Entretiens sur les Vies et sur les Ouvrages des Plus Excellens Peintres Anciens et Modernes*, vol. 3 (Paris, 1725), pp. 438–39; trans. in Washington (note 40), p. 19.

42 Bellori, Brown (note 38), (1991), p. 17.

43 Writing about the preparatory drawings for engravings, Bellori (note 38) specifically mentioned the subject of the Battle of the Amazons, which we know from a letter from Rubens written in January 1619 was with other subjects being engraved after his paintings. A drawing of this subject connected with the engraving by Lucas Vorsterman exists at Christ Church, Oxford (J. Byam Shaw, *Drawings by Old Masters at Christ Church*, vol. 1, no. 1377 (Oxford, 1976); in addition, there are eight highly finished preparatory drawings for other engravings after Rubens (all in the Cabinet des Dessins, Musée du Louvre, Paris), that have been attributed to Van Dyck (see H. Vey, *Die Zeichnungen Anton Van Dycks*, 2 vols., [Brussels, 1962]), nos. 160–67, pls. 202–9; for a recent discussion of the problem, see C. Brown, *The Drawings of Anthony van Dyck*, exh. cat. (New York and Fort Worth, 1991), no. 42.

44 Bellori's statement (Brown (note 43) [1991], p. 17) is supported by the fact that in 1661 and 1692 the cartoons were sold under Van Dyck's name (S. Barnes in Washington (note 40), p. 19, citing F. van Branden, *Geschiedenis der Antwerpsche Schilderschool* (Antwerp, 1883), p. 702, n. 1). The most recent discussion of the cartoons in the Metropolitan Museum of Art, (R. Baumstark, *Liechtenstein: The Princely Collections*, exh. cat. (New York, 1985–86), pp. 338–55), proposes that they are the work of Rubens and his studio, and not solely by Van Dyck.

45 Rubens to Carleton, April 28, 1618, in R. S. Magurn, *Letters of Peter Paul Rubens* (Cambridge, Mass., 1955) p. 61.

46 Hervey (note 9), p. 175; Vercellini was accompanying the Countess of Arundel on her visit to Rubens's studio; for further discussion, see below.

47 For an account of the commission, see J. R. Martin, *The Ceiling Paintings of the Jesuit*

Church in Antwerp, Corpus Rubenianum Ludwig Burchard, part 1 (London/New York, 1968.

48 In recent years the painting has sometimes been attributed to Van Dyck himself, but see H. Vlieghe, *Rubens Portraits*, Corpus Rubenianum Ludwig Burchard, vol. II (London and New York, 1987), no. 89.

49 The attributions of both versions of this subject have varied between Rubens and Van Dyck; for the most recent summary, see Washington (note 40), no. 10.

50 R. de Piles, *The Art of Painting and the Lives of the Painters* (trans. from French) (London, 1706), p. 304.

A sketchbook at Chatsworth, clearly inspired by Rubens's lost Pocket Book and containing, among other studies, a number of drawings after the antique and illustrated notes on architecture, was published by M. Jaffé, *Van Dyck's Antwerp Sketchbook*, 2 vols. (London, 1996) as an early work (circa 1615–20) by Van Dyck.

The attribution was accepted by the majority of scholars, including myself. But recently J. Müller Hofstede ("Van Dyck's Authorship Excluded: The Sketchbook at Chatsworth," in S. Barnes and A. Wheelock, eds., *Van Dyck 350* (note 37), pp. 49–60, with references to previous literature) has argued that the book cannot have been drawn until the late 1630s at the earliest.

51 Bellori, Brown (note 43), (1991), p. 17.

52 What may be a later reflection of Rubens's attitude toward Van Dyck's role as a portraitist is the curious fact that Rubens never, despite his undoubtedly close relationship with Charles I, made a straightforward portrait of the king while he was in London.

53 For a recent discussion, see E. Waterhouse, *Anthony van Dyck, Suffer Little Children to Come unto Me* (Masterpieces in the National Gallery of Canada No. 11), (Ottawa, 1978); but against the accepted identification of the family as that of Rubens, see Washington (note 40), no. 18.

54 In a later version of the subject, executed either just before or during his stay in Italy, in the Alte Pinakothek, Munich (see G. Glück, *Van Dyck, des Meisters Gemälde, Klassiker der Kunst XIII*, 2nd ed., (Stuttgart and Berlin, 1931), p. 66), it has been suggested that he used his own features for the saint (see J. Martin and G. Feigenbaum, *Van Dyck as Religious Artist*, exh. cat., (Princeton: University Art Museum, 1979) p. 117). A similar claim has been made for the version of the subject in the National Gallery of Scotland, Edinburgh in A. McNairn, *The Young van Dyck*, exh. cat., (Ottawa, 1980), p. 35.

55 The Van Dyck set (Glück (note 54), pp. 37–43) is now widely dispersed; for a recent discussion, see Washington (note 40), pp. 130–4.

56 Both pictures are in the collection of the Prince of Liechtenstein, Vaduz.

From the same year there is a pair of smaller panels, similarly dated and inscribed with the sitters' ages (both 60), in the Gemäldegalerie, Dresden (Glück (note 54), p. 80).

57 It is an indication of the similarity in style between the two artists at this date that a number of scholars, including Glück and Burchard, believed that the portrait of Jan Vermoelen was by Van Dyck rather than by Rubens; see Vlieghe (note 48), pp. 199–200.

58 Bellori, Brown (note 43), p. 22.

59 Only one portrait is known today, in the Hermitage, St. Petersburg (Glück (note 54), p. 355).

60 R. de Piles, *Cours de Peinture par Principes*, (Paris, 1708), pp. 291–3; trans. in C. Brown (note 43) (1991), pp. 34–5.

61 From the time of the Italian period onwards, there are numerous drawings connected with portraits, both studies of heads and poses (see, for example, fig. 53). For a discussion of

these working studies, see Brown (note 43), (1991), pp. 32–34.

62 From other existing sheets, mostly made after 1620, and therefore after Van Dyck had left his circle, we can determine that Rubens made two kinds of drawings, although lack of evidence makes it impossible to say that this represented his invariable practice; a sketch of the pose, indicating the costume, and a carefully wrought study of the head, usually *à trois crayons*. (For one unusual study of a head, see fig. 49).

63 Almost certainly executed before Van Dyck went to Italy, it may well have been painted in England (see W. Liedtke, *Flemish Paintings in the Metropolitan Museum of Art,* vol. 1, (New York, 1984), pp. 67–68.)

64 For a discussion of the attribution and identification of the sitter, see O. Millar, *Van Dyck in England*, exh. cat. (London: National Portrait Gallery, 1982), no. 1. It is, however, more likely to have been painted in Rome in 1622/23 than in London in 1620/1 (see Washington (note 40), no. 30).

65 As Millar (note 64), (1982), no. 2, pointed out, this is probably the first occasion on which the artist introduced a curtain with a woven pattern, a feature that was to occur in many later portraits.

66 Bellori, Brown (note 43), p. 19.

67 F. Vercellini (?) to the Earl of Arundel, Antwerp, July 17, 1620; Hervey (note 9), p. 175.

68 Letter from Thomas Locke, Clerk of the Privy Chest, to William Trumbull, the English agent in Brussels, October 28, 1620; *B. L. Trumbull MSS: Miscellaneous Correspondence*, vol. 11, fols. 144 ff. (see D. Howarth, "The Arrival of Van Dyck in England," *Burlington Magazine,* 132 (1990), p. 709.)

69 Tobie Mathew to Carleton, November 25, 1620; Sainsbury (note 35), p. 54.

70 W. Hookham-Carpenter, *Pictorial Notices: Consisting of a Memoir of Sir Anthony Van Dyck* (London, 1844), p. 6.

71 Privy Council register, February 28, 1621; Hervey (note 9), p. 187. Arundel's involvement may indicate, as C. Brown, *Van Dyck* (Oxford, 1982) (note 1) (1982), p. 57, has suggested, that Van Dyck was still in his service and that the artist was going to Italy under the earl's auspices.

72 For a discussion of Rubens's picture and the exchange, see A. Balis, *Rubens Hunting Scenes,* Corpus Rubenianum Ludwig Burchard, Part 18, vol. 2 (London and Oxford, 1986), pp. 136–38.

73 Millar (note 64), (1982), no. 66, has proposed that a drawing of a man's head (Institut Néerlandais, Paris), with an old inscription on the back can be identified as a portrait study of James I by Van Dyck, suggesting that the latter had portrayed the king in a painting, now lost. The attribution of the drawing has not been generally accepted; see M. Levey and C. Brown in their reviews of the exhibition in *Burlington Magazine,* 25 (1983), pp. 109–10, and *Kunstchronik, 36* (1983), p. 271 respectively.

Millar (note 64), (1982), p. 14 has also suggested that James I may have wanted to enlist Van Dyck in the production of designs for the newly established tapestry factory at Mortlake, for which another Flemish artist, Abraham van Blyenberch, was already working. Apart from his linear style of painting, which would have been appropriate for the medium, Van Dyck had already had experience producing cartoons for tapestries when he worked with Rubens on the *Decius Mus* series several years earlier.

74 This painting can be reasonably identified as the "Vandyke One great Peice being Scipio" mentioned, in the Duchess of Buckingham's inventory of 1635, as hanging in the hall at York House, London (R. Davies, "An Inventory of the Duke of Buckingham's Pictures,

etc.," *Burlington Magazine*, 10 (1906–7), p. 379). There is also an undated record of a payment to Van Dyck by Endymion Porter on behalf of the Duke of Buckingham (see O. Millar, "Van Dyck's *Continence of Scipio* at Christ Church," *Burlington Magazine*, 93 (1951), p. 125).

The painting has recently been much interpreted; for a brief summary of the various, sometimes fanciful, opinions, see J. Wood, "Van Dyck's Pictures for the Duke of Buckingham," *Apollo* 136 (1992), pp. 37–47, to which should be added R. Harvie, "A Present from "Dear Dad"? Van Dyck's *The Continence of Scipio*," *Apollo* 138 (1993), p. 224, who, following a suggestion of G. Martin ("The Age of Charles I at the Tate," *Burlington Magazine*, 115 (1973), p. 59), believes that Scipio may bear the likeness of James I and, furthermore, that the latter was responsible for commissioning the picture as a wedding present for Buckingham.

Since Allucius is clean shaven and Adonis bearded, it does not seem likely that Buckingham served for both likenesses.

75 See M. Jaffé, "Van Dyck's 'Venus and Adonis,'" *Burlington Magazine*, 132 (1990), pp. 696–703, and Washington (note 40), no. 17. The identification of Venus with the duchess is not entirely persuasive if the former is compared with the image in Honthorst's *Duke of Buckingham with his Family*, in the Royal Collection (C. White, *The Dutch Pictures in the Collection of H.M. The Queen* (Cambridge, 1982), no. 75, pl. 67).

The picture is clearly related to another probably earlier version of the subject by Van Dyck, now in the art trade in Vienna (Jaffé, fig. 37).

76 See J. Harris, "The Link between a Roman Second-Century Sculptor, Van Dyck, Inigo Jones and Queen Henrietta Maria," *Burlington Magazine*, 95 (1973), pp. 526–30. The original relief is recorded in Arundel's possession in a dated and inscribed drawing

by John Webb of 1639 (Harris, fig. 54); Inigo Jones also saw it at Arundel House and thought that it came from the Temple of Minerva at Smyrna.

Rather inexplicably, since the artist was only born in 1622 and never visited England, Pieter Boel included the frieze in a still-life painting, which is now in the picture gallery at Kromeriz, Schloss Kremsier (see L. Konecny, "Überlegungen zu einem Stilleben von Pieter Boel . . . ," *artibus et historiae*, 7 (1983), pp. 125–39, fig. 1, suggesting that it was based on a lost drawing by Hollar). I am grateful to Michael Vickers for drawing my attention to this work.

77 Howarth (note 2), pp. 156–57, following G. Parry, *The Golden Age Restor'd: The Culture of the Stuart Court*, 1603–42, (Manchester, 1981), p. 139. Jaffé (note 75), p. 697 says that it "was presumably painted at the behest or suggestion of Lord Arundel . . . for Lord Buckingham."

78 This is the opinion of Harris, (note 76) (1973), p. 529, followed by Brown (note 71) (1982), p. 56, and Millar (note 64) (1982), no. 3. Both points of view are proposed in Washington (note 40): commissioned by Arundel (A. Wheelock [note 39], p. 292, and, by inference, J. D. Stewart, p. 74, note 1); commissioned by Buckingham (S. Barnes, p. 158). For a rejection of Howarth's argument (p. 157) that Buckingham was not collecting antique sculpture before 1624, see Wood (note 74) (1992), p. 45, n. 12.

79 Sir Dudley Carleton in The Hague to Lord Arundel, August 18, 1618; Hervey (note 9), p. 144.

80 Interestingly, the portraits appear to have been commissioned by Carleton rather than by Arundel who, however, according to the artist, liked them so much when they were finished that he insisted on keeping them for himself and commissioned a smaller version on one canvas to be sent to The Hague as a consolation present for Carleton (see letter

from Mytens to Carleton, dated London, August 18, 1618; Hervey (note 9), p. 143). What may be the small repetition in one picture is now in the collection of the Duke of Norfolk (Millar (note 28), [1972], no. 3, repr.). Writing to thank Arundel for this, Carleton observed, "I wish he had been so happie in hitting my Lady as he hath perfectly done your Ldp, but I observe it generally in woemens pictures, they have as much dis-advantage in ye art as they have advantage in nature." (Hervey (note 9), p. 143).

In addition to Van Somer and Mytens, there were a number of other artists from the Netherlands, such as John de Critz the Elder (1552?–1642), Marcus Gheeraedts the Younger (1561/2–1636), Abraham van Blijen-berch (fl. 1617–22), and Cornelis Jonson (1593–1661), who was born in England of Flemish parents.

81 For the most recent discussion of the picture and the identity of the male sitter, see Vlieghe (note 48), no. 72; K. Downes ("Oxford, Arundel's quartercentenary: A Book and an Exhibition," *Burlington Magazine*, 128 (1986), p. 162), believes, however, that, since Carleton was ambassador to the United Provinces and therefore resident in The Hague, Francesco Vercellini is the more likely candidate. (The ambassador in Brussels was William Trumbull.)

82 Hervey (note 9), p. 175.

83 Walker; Howarth (note 2), p. 221.

84 Birch (note 26), p. 419; Hervey (note 9), p. 264.

85 Rubens to Pierre Dupuy, August 8, 1629; Magurn (note 21), pp. 320–21.

86 Both are in London, in the National Gallery (2968; F. Huemer, *Rubens Portraits* [Brussels, 1977]) no. 4, fig. 48), and in the National Portrait Gallery (2391; Huemer, no. 5b, fig. 53).

87 See G. Adriani, *Anton van Dyck: Italienisches Skizzenbuch* (Vienna, 1940).

88 Another tradition, supposedly going back to Sir Peter Lely, states that the king's request for Van Dyck to return came as a result of his being greatly impressed by the latter's *Portrait of Nicholas Lanier* (Kunsthistorisches Museum, Vienna).

89 Bellori, Brown (note 43), (1991) p. 20. It should be noted that Bellori did not mention the first journey to England, but in the context of what he was saying he was clearly referring to Charles I.

90 The former is in the collection of the Duke of Norfolk at Arundel Castle (Millar (note 64) (1982), no. 21) and the latter, inscribed with the date 1635, is in the Howard collection at Greystoke (Millar (1982), no. 19).

A drawing in the British Museum (Vey, note 43, no. 229, pl. 276) suggests that Van Dyck painted a bust-length portrait of Arundel about this time, which appears to have been the source of the engraving by Lucas Vorster-man the Elder (*Hollstein's Dutch and Flemish Etchings, Engravings and Woodcuts 1450–1700* [Rosendaal, 1993]) vol. 43, pp. 128–29, no. 132), although the sitter in the latter looks younger.

91 In addition to the version reproduced, there is another probably autograph version in the Kunsthistorisches Museum, Vienna (Glück (note 54) p. 472). For a discussion of the merits, see Millar (note 28), (1972), no. 59.

To record an earlier historical event, Arun-del's inglorious expedition to Scotland at the head of an English army in 1637, the earl commissioned an etched equestrian portrait by Wenceslaus Hollar (R. Godfrey, *Wences-laus Hollar: A Bohemian Artist in England* [New Haven, 1994]) no. 53, repr.

92 The watercolor is in a private collection. Millar (note 28), (1972), no. 134, notes that the grandchildren appear to have been painted *ad vivum*. The painting has also been accepted as by Fruytiers, but Millar believes that it is only a copy by another hand.

93 For a discussion of Van Dyck's supposed project and other related works almost certainly not by Van Dyck, see Vey (note 43), pp. 295–96; J. Rowlands, "Sketch for a Family Group by Van Dyck," *Master Drawings,* 8 (1970), pp. 162–66; Millar (note 64), (1982), under no. 77; D. Howarth, N. Penny, *et al.* (note 6), under no. 11; C. Brown, "Van Dyck's *Pembroke Family Portrait:* An Inquiry into Its Italian Sources," in Washington (note 40), p. 44, n. 10.

94 Clarendon; Howarth (note 2), p. 219.

BIBLIOGRAPHY

ADRIANI, G. *Anton van Dyck: Italienisches Skizzenbuch.* Vienna, 1940.

BARNES, S., and WHEELOCK, eds. *Van Dyck 350.* Washington, D.C., 1994.

BELLORI, G. P. *Le vite de pittori, scultori ed architetti.* Rome, 1672. Translated by C. Brown, 1991.

BROWN, C. *Van Dyck.* Oxford, 1982.

———. *The Drawings of Anthony van Dyck.* Exh. cat. New York: Pierpont Morgan Library, and Fort Worth: Kimbell Art Museum, 1991.

HYDE, EDWARD, Earl of Clarendon. *History of the Rebellion and Civil Wars in England.* Edited by W. Macray. 2 vols. Oxford, 1888. (See Howarth, pp. 219–20.)

GLÜCK, G. *Van Dyck, des Meisters Gemälde, Klassiker der Kunst,* vol. 13. 2nd. ed. Stuttgart and Berlin, 1931.

HAYNES, D. *The Arundel Marbles.* Oxford, 1975.

HERVEY, M. *The Life, Correspondence and Collections of Thomas Howard, Earl of Arundel.* Cambridge, 1921.

HOWARTH, D. *Lord Arundel and His Circle.* New Haven and London, 1985.

HUEMER, F. *Rubens Portraits.* Corpus Rubenianum Ludwig Burchard, Part 19, vol. 1. Brussels, 1977.

JAFFÉ, M. *Van Dyck's Antwerp Sketchbook.* 2 vols. London, 1966.

LARSEN, E. *The Paintings of Anthony van Dyck.* 2 vols. Freren, 1988.

MCNAIRN, A. *The Young van Dyck.* Exh. cat. National Gallery of Canada, Ottawa, 1980.

MAGURN, R. S. *Letters of Peter Paul Rubens.* Cambridge, Mass., 1955.

MARTIN, J., and G. FEIGENBAUM. *Van Dyck as a Religious Artist.* Exh. cat. University Art Museum, Princeton, 1979.

MILLAR, O. *The Age of Charles I: Painting in England 1620–1649.* Exh. cat. Tate Gallery, London, 1972.

———. *Van Dyck in England.* Exh. cat. National Portrait Gallery, London, 1982.

HOWARTH, D., N. PENNY, et al. *Patronage and Collecting in the Seventeenth Century: Thomas Howard, Earl of Arundel.* Exh. cat. Ashmolean Museum, Oxford, 1985.

PARRY, G. *The Golden Age Restor'd: The Culture of the Stuart Court, 1603–42.* Manchester, 1981.

PEACHAM, H. *The Compleat Gentleman.* 2nd. ed. London, 1634.

SAINSBURY, W., ed. *Original Unpublished Papers Illustrative of the Life of Peter Paul Rubens.* London, 1859.

VEY, H. *Die Zeichnungen Anton van Dycks.* 2 vols. Brussels, 1962.

VLIEGHE, H. *Rubens Portraits.* Corpus Rubenianum Ludwig Burchard, Part 19, vol. 2. London and New York, 1987.

WALKER, SIR EDWARD. *Historical Discourses upon Several Occasions.* Edited by H. Clopton. London, 1705. (See Howarth, pp. 221–22.)

WHEELOCK, A., S. BARNES, J. HELD, et al. *Anthony van Dyck.* Exh. cat. National Gallery of Art, Washington, D.C., 1990.

Foldout

Anthony van Dyck
Thomas Howard,
The Earl of Arundel
(1585–1646), circa
1620/1. Oil on canvas,
102.8 × 79.4 cm
(40½ × 31¼ in.).
Malibu, J. Paul Getty
Museum (86.PA.532).

ACKNOWLEDGMENTS

The subjects of both Van Dyck and the cultural ambience of early Stuart England have been much discussed in recent years. In the case of Van Dyck there have been three very notable exhibitions of both paintings and drawings—at the National Portrait Gallery, London (1982), the National Gallery of Art, Washington (1990–1), and at the Pierpont Morgan Library, New York (1991)—all of which were accompanied by catalogues of real scholarly substance. I am greatly indebted, as anyone conversant with the field will immediately realize, to these and the other scholarly works cited in the bibliography.

For help with various points, I have to thank Miss Elizabeth Powis and Mr. Michael Vickers. Sir Michael Levey and Sir Oliver Millar, who most kindly read the text, provided helpful critical comments, for which I am deeply grateful.

It has been a pleasure, as a former guest scholar at the Getty Museum, to make some offering to an institution which has provided such a happy and stimulating haven for study over the period of a sabbatical. In particular I would like to thank Mr. Mark Greenberg and his colleagues at the museum for the care they took in editing and designing the book. I would also like to acknowledge the invaluable help of my secretary, Mrs. Vivien Stchedroff.